MURDER & MAYHEM
——— IN THE ———
CRESCENTA VALLEY

MURDER & MAYHEM
── IN THE ──
CRESCENTA VALLEY

GARY KEYES & MIKE LAWLER

Charleston · London

THE
History
PRESS

Published by The History Press
Charleston, SC 29403
www.historypress.net

First published 2013

Manufactured in the United States

ISBN 978.1.60949.997.6

Library of Congress CIP data applied for.

Notice: The information in this book is true and complete to the best of our knowledge. It is offered without guarantee on the part of the author or The History Press. The author and The History Press disclaim all liability in connection with the use of this book.

CONTENTS

INTRODUCTION

The foothills of Glendale and Los Angeles are peaceful and tranquil. Students in high schools in the area consider the communities that compose the foothills to be boring. They claim, "Nothing ever happens here. There is nothing to do." They can't wait until they graduate and move to where the action is. They do not realize that in ten years time, they will be fighting to get back into these communities to raise their children. They are also unaware that the foothills community has its dark side, a history they might find all too interesting.

This work is not intended to be a comprehensive history of violence in the foothill communities. No attempt has been made to cover each and every act of violence that has occurred in our communities. Rather, it is an attempt to deal with the most interesting and significant acts of violence. The intent is not to horrify, though this may happen. The dark happenings in the foothills are not darker than any other residential communities of the same size. We hope that this history will be both informative and thought provoking. We hope it will give greater understanding and appreciation of the area in which we live.

Chapter 1
EARLY YEARS

European Invasion

The settlement of California was accompanied by a great deal of violence, some of it unintended. Even before the first attempts at settlement were made, great changes had occurred in the flora and fauna of California due to Spanish exploration. California had been isolated from the world's ecology for twelve thousand years. Our deserts, mountains and seas had protected and sheltered the native ecology. Juan Rodriguez Cabrillo arrived in 1542 with two ships. He was followed by Sebastián Vizcaíno in 1602 with three ships. The explorers brought with them literal seeds of change on their clothing and gear. They brought heartier and more competitive plants from the Mediterranean basin that rapidly supplanted much of the original plant life of California. They also brought microbes that reduced the defenseless Indian population from an estimated 200,000 to roughly 20,000.

The mission system was traumatic to the Indians' social and sexual lives. In an attempt to save Indian souls, the padres found it necessary to suppress many aspects of Indian life, such as polygamy. They accomplished their purpose with tactics that we find abhorrent today, including beatings, imprisonment and humiliation.

Early life in California was a paradise for the Spanish and, later, for the Mexicans. The living was easy with its economy based on cattle, which were raised for their hides. Life was a constant round of celebrations, births, weddings and religious feast days. When Don Pio Pico married Maria

Alvarado in February 1834, the feasting went on for eight days, and every resident of Los Angeles was invited. The Mexicans were great horsemen. The horse was integral to their way of life. They raised them and used them in competitions such as racing, which was usually accompanied by gambling.

INDIAN ABUSE AND THE BETRAYAL OF TOYPURINA, 1785

In 1769, with the founding of the first Spanish mission in California, two major cultures clashed. One, the Indians', was fragmented into several subcultures, or tribes, many of which were by nature peaceful and trusting, with a religion and traditions that were thousands of years old. The other culture, that of the invading Spanish, was well organized and technologically superior. They easily dominated the Indians, eventually inadvertently killing the majority of them through disease. Traditionally, the victor writes the history, and so for over 250 years, we have been told that the Indians were peacefully and willingly assimilated into the mission system. In about the last 50 years, however, a different story has begun to emerge, a story of misery, abuse of Indians both in and out of the mission system and, arguably, California's only brush with institutionalized slavery. Although some of the sources of this second history are controversial, others are eyewitness accounts written during that time. The following is a different story of the missions than has been told before, some of it touching on our own Crescenta Valley.

There were three villages in the Crescenta Valley area. Tujunga was near where Big Tujunga Canyon opens out into the San Fernando Valley. Hahamongna was located on the plateau overlooking the Arroyo Seco, about where Jet Propulsion Laboratory (JPL) is today. The third, Wikangna, was the closest to La Crescenta, although we still don't know exactly where it was located. The most likely spot is Las Barras Canyon, where the Verdugo Hills Golf Course is today. All three villages were heavily drawn down by mission recruitment or disease, and each, as far as we know, disappeared during the mission era.

When the Spanish first arrived to establish San Gabriel Mission, the native population lived in a veritable paradise. California's native population numbers were among the highest on the continent. Life was easy—good weather and good food—just like today. The Indians had a varied diet, and food was plentiful. They lived a free and easy lifestyle, living where the living

was easy: the cool canyons in the hot summers, sheltered under the oaks in our mild winters. Their cultures were for the most part peaceful, and although there were conflicts between the tribes, their wars were little more than dangerous sport.

The Spanish, on the other hand, were fierce and tough, with a focused goal of conquest and occupation. Their objectives were to establish a foothold for Spain on a new continent and to save the souls of the current occupants and make them good subjects of the crown.

Once sites for the missions were selected, labor was needed immediately. Initially, some willing converts trickled in. Larger numbers followed, but why they were drawn to the missions becomes murky. Perhaps they were attracted by the pageantry of the Catholic religion or the deep spiritual commitment of the priests. But on the other hand, stories have been told of Indian children being kidnapped by the priests so that their parents would be forced to follow them to the missions. There are accounts of "recruitment with military assistance," a polite term for armed raids on villages to collect workers. What is clear from the history books is that, once they committed to the missions, there was no going back to their village life.

Existence in the mission was hard. New converts, or neophytes, fresh from village life where their diets were varied and rich were probably shocked by the rations handed them. Breakfast was barley mush, followed by a lunch of barley mush mixed with beans or peas and a dinner of, you guessed it, barley mush. Meat from the mission cattle was only occasionally given to the Indian workers. Overall, the hardworking laborers were given about two thousand calories a day, enough to survive on but suboptimum for good health while doing physical labor. The neophytes were segregated by sex, the men and women being locked into separate quarters each night. These cells were badly overcrowded, poorly ventilated and unsanitary. For the women who did manage to become pregnant, abortion and infanticide became increasingly common as time went on.

With the cramped conditions and poor diet, disease on a large scale was inevitable. Dysentery, smallpox and influenza killed thousands of neophytes, and the mission fathers had little in the way of medicine to combat this. The reduction in workers for the mission by disease and the lack of reproduction made raids into surrounding villages more widespread and aggressive.

Punishment for the smallest infraction was common and brutal. Flogging, confinement in stocks and hard labor were freely handed out. One researcher, using mission records, compiled a sampling of 362 Indians punished, and the recorded punishments seem harsh: 70 percent were flogged by fifteen

to over two hundred lashes, 57 percent were imprisoned and forced to do hard labor from one month to four years and 36 percent were both flogged and imprisoned. An unlucky few were executed for crimes such as homicide, conspiracy or robbery. Even one contemporary priest, Padre Horra of Mission San Miguel, complained to the viceroy in Mexico in 1799, saying, "The treatment shown to the Indians is the most cruel I have ever read in history. For the slightest things, they receive heavy flogging, are shackled and put in the stocks, and treated with so much cruelty that they are kept whole days without water."

In such brutal conditions, it seems natural that the neophytes would attempt to escape from their captors, and indeed, they did. Runaways were a constant problem for the mission fathers. On a practical level, Indians escaping from the mission depleted a constantly strained labor force. If allowed, others would follow. But on a spiritual level, it suggested that the priests had failed their holy duty and that Christianity was not the moral force they believed it to be. Runaways had to be dealt with strongly, and the mission soldiers were sent to collect the fugitives in as brutal and swift a fashion as possible. Harsh punishment awaited them back at the mission, and if those runaways had sheltered in a village, the villagers were punished as well. This must have spread terror across the land and caused some villages to dissolve into the surrounding mountains. It can be imagined that it was at this point that the villages of Tujunga, Wiqangna and Hahamokngna scattered to the Verdugo and San Gabriel Mountains.

The Indian population seems to have been too demoralized by abuse and disease to have put up a fight on a large scale, and for the most part, the only resistance was that of running away. But there were examples of revolts and attacks on the missions. In 1769, the party of Spaniards attempting to establish the first mission at San Diego was attacked only a month after arrival. Six years later, the San Diego Mission was attacked again by nearly one thousand Indians, and several Spaniards, including a priest, were killed. In 1781, a force of Indians attacked a mission farther inland on the Colorado River, killing everyone there and burning the entire operation to the ground. This attack was so effective that the Spanish never rebuilt there. San Francisco was the next site of resistance, with a nonviolent revolt. The couple hundred mission Indians living there all deserted at the same moment. At a signal, they simply took off in every direction. The 1824 revolt at Mission La Purisima was the most spectacular. During one of the many floggings of Indians at Mission Santa Ynez near La Purisima, a huge fight broke out, and part of that mission was burned. With tensions high, a force

of two thousand Indians attacked and took Mission La Purisima, holding it for a month before the Spanish regrouped and sent hundreds of armed and mounted soldiers backed by artillery to retake the mission.

But perhaps the most fascinating revolt took place at Mission San Gabriel in 1785. It involved Indians from the Crescenta Valley area and was led by a charismatic female shaman. Toypurina was already a young girl when the Spanish first showed up in 1771 and so grew up watching her fellow Indians' initial attraction to the mission and the disillusionment soon after. She was probably influenced by an ugly incident that occurred soon after the Spanish arrived at the site where San Gabriel Mission was to be built: the wife of a local chief was raped by mission soldiers. When her husband protested and attacked the soldiers, they killed him. They cut off his head and placed it on a post as a warning to others.

As Toypurina grew up, she became a medicine woman and skilled at magic spells. It was said that she had the power to kill men with just her will. She was an influential leader among the non-mission Indians. Her brother was the chief of the village at Tujunga, and she traveled between all the villages, healing and casting spells.

In 1785, a disgruntled mission Indian named Nicolas Jose contacted the twenty-four-year-old Toypurina. He had been in trouble at the mission before when he fought with one of the mission soldiers over a woman, and now, he was fed up with the mission life. He asked Toypurina to kill the Spanish at San Gabriel with her magic and lead a revolt.

Toypurina agreed to do this, formulated a plan and gathered support around the villages. She recruited her brother, the chief of Tujunga, and the chief of Hahamongna to lead warriors from the eight villages she had convinced to join the revolt. She told them that she would kill the fathers with magic and the warriors could finish off the leaderless soldiers with their arrows. But the wily corporal of the guard, Jose Maria Verdugo, the very man who would later own Glendale and the Crescenta Valley, got wind of the plot. The soldiers would be ready.

On a moonless night, Toypurina, two chiefs and dozens of warriors scaled the walls of the mission and dropped to the ground where a trap waited for them. They rushed to the priests' rooms, where two figures in priestly robes lay motionless, seemingly dead by Toypurina's magic. Toypurina entered the room, followed by the warriors, when suddenly, the two dead priests, actually disguised soldiers, sprang to their feet with a shout. More soldiers rushed in behind the war party. The warriors panicked and scattered, leaving Toypurina and about twenty chiefs and warriors captured.

Two months later, they put the leaders on trial for rebellion. At this point, the leaders of the revolt turned on Toypurina. They testified that Toypurina was a witch, and they had only gone along with the plot because they were afraid of her. They were probably terrified that they would be executed and hoped to weasel out of a death sentence. Finally, Toypurina was called in. She was led in with her hands tied behind her back, and she angrily kicked over the stool she was to sit on while testifying. She was fiercely defiant and disgusted with her former followers. She spat out these words: "I hate the padres and all of you, for living here on my native soil,

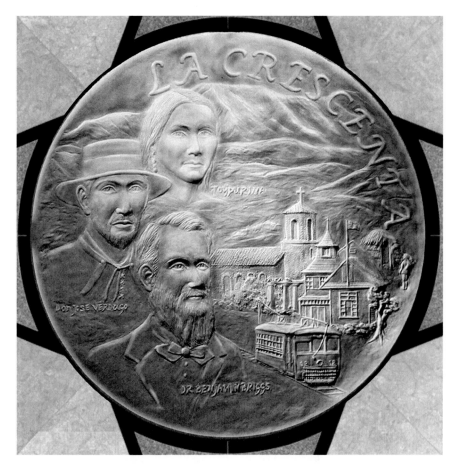

This large bronze floor plaque is in the lobby of the new La Crescenta Library. It sculpturally represents several significant historical landmarks of the Crescenta Valley, along with the images of three historical individuals who represent the three eras of human habitation of the valley. In front, Dr. Benjamin Briggs represents the American period, Don Jose Verdugo represents the Spanish era and a fanciful image of Toypurina represents the Indian era. *Courtesy of the Historical Society of the Crescenta Valley.*

for trespassing upon the land of my forefathers and despoiling our tribal domains. I came to inspire the dirty cowards [Indians] to fight, and not to quail at the sight of Spanish sticks that spit fire, and not retch at the evil smell of gunsmoke—and to be done with you white invaders!"

The rebels were flogged, and the leaders were taken away in iron shackles. Toypurina was held at Mission San Gabriel for another two years while Mexico City pondered her punishment. While in captivity, she was baptized—whether it was willingly, we'll never know. Interestingly, the Spanish governor of California, who had attended her trial and witnessed her defiance, argued for leniency. Perhaps he didn't want to create a martyr. Ultimately, she was exiled to the mission at Carmel, where she died ten years later.

Toypurina was a charismatic leader, but she emerged perhaps at the wrong time and place in history. Her story is very sad. The Indians around the Crescenta Valley were too demoralized and fragmented by disease and oppression to follow any leader into an effective resistance. She was abandoned to her fate by the very people she was trying to free from bondage.

On the floor of the lobby of the La Crescenta Library is a bronze plaque dedicated to the history of the valley. For each era of man's habitation of the Crescenta Valley, a single personality from history was chosen. To represent the thousands of years of Indians living on the land, an image of Toypurina was sculpted. She was the last gasp of a dying culture.

BLOOD SPORTS

Sports of the nineteenth century were often violent. While ratting and eye gouging were popular in the rest of the country, Californians preferred the even more brutal cockfights and dogfights. We know from Harold McCracken's book *The Beast that Walks like a Man* that bear and bull fights occurred at least as close as the San Fernando Mission in 1854 and 1857. Bear and bull baiting was made possible by California's cattle-based economy. The proliferation of cattle provided the grizzly bear with a constant and plentiful food supply. The grizzly population spiked at an estimated ten thousand statewide. In some areas, it was said that you could see several bears in an afternoon ride. Bored *vaqueros* (cowboys) would rope bears to fight bulls in fiestas. They must have been very bored. Capturing a grizzly was sport at its ultimate. It required skill, horsemanship and rope work. Four brave and foolish vaqueros would ride out on specially trained horses. (The

horses had to be trained since they were naturally afraid of bears. Horses are not necessarily as dumb as their riders.) The vaqueros would surround the bear, and the bear would rise on its hind legs, standing taller than the horse. One of the *lazadoris* (ropers) would rope one of the forepaws and each leg. The all-time champion was Ramon Ortega, who claimed to have roped over two hundred grizzlies. In the arena, the bear would be chained to a post. In these bloody conflicts, the bear usually won as the bull had a weakness. When it became winded and its tongue began to hang out, the bear would seize it and pull it out. The last bear and bullfight occurred at Pala with a grizzly captured in the Palomor Mountains. The bear killed three bulls but was killed by the fourth. The sport was banned in California in the 1880s because of changing social mores.

This bloody sport was only a small reason for the demise of the California grizzly. If cattle were the reason for the grizzly population explosion, they were also the reason for its demise. To protect their cattle from depredations by grizzlies, cattlemen had the bears hunted down. The last grizzly found in Southern California was killed in Sunland in 1916. The last California grizzly was killed in 1920 in Tulare County.

TIBURCIO VÁSQUEZ, 1874

Any account of the wild side of the foothills must start with one of their earliest and most accomplished residents: Tiburcio Vásquez. The story of Vásquez the bandit is well known. His life is the stuff of legend. His story has all the necessary elements. It is about adventure, violence, shootouts, robberies, lynchings, love affairs and betrayals. It is set against the backdrop of racism and social injustice that accompanied the California gold rush. His exploits deserve the treatment of movies and stage. In fact, a stage play was produced and performed during his lifetime. A movie, *Pinnacles*, was produced in 1919. Seven books have been written about Vásquez's career. John Boessenecker's book *Bandito* is considered the definitive account of Vásquez and his many adventures. Vasquez's career began in 1852, when, at age seventeen, a police officer was shot through the heart during a brawl at a local dance. Vásquez was implicated in the killing and fled the scene.

Vásquez was born on August 11, 1835. He was the ninth of ten children. He grew up in Monterey, which was considered one of the most violent places in U.S. history at that time. He grew up with banditos and gamblers.

He was both. Vásquez spent ten of his forty years in San Quentin, from which he escaped twice. He stood five feet, seven inches tall and weighed 130 pounds. He was considered to be handsome and charming. He was brave, vain and egotistical. He considered himself a lover. He took risks with his love life. He fathered three children with three different women, one of them being his niece Felicita. Twice his affairs nearly cost him his life. He was fond of the wives of his men, including Rosaria Levina. Her husband, Abdon, took offense and left the gang. Vásquez kidnapped Rosaria and left her pregnant in the mountains, giving the lie to his reputation for gallantry. Vásquez represented himself as a Robin Hood. It's interesting how many outlaws of the Old West thought of themselves in this way. Vásquez felt he was forced into a life of crime by the Anglo population. However, he was the only member of his family to go bad. Whatever the truth of the matter, sections of the Mexican population held him in a positive light. They considered him a protector against the Gringos.

Early in his life, Vásquez rejected the church and the values of hard work and self-restraint. He chose, instead, to fill his life with leisure, expensive women and sexual freedom. Vásquez was a fine horseman able to ride sixty miles in a day. He was blessed physically with good health and stamina, which allowed for quick recovery from his six separate bullet wounds. He was known to have killed at least two men. He would hang for one of those murders.

Tiburcio Vásquez was familiar with the canyons and trails of the San Gabriels above the Crescenta Valley and regularly drove herds of stolen horses up to Chilao Flats near where Newcomb's Café is today. There, he would rebrand them and sell them north. His movements are for the most part unknown today, but one route to Chilao would have been Big Tujunga Canyon, which makes it fun to remember that the original name of Honolulu/Tujunga Canyon Road on the east side of Crescenta Valley was "Horse Thief Trail."

San Gabriel Mountains historian Will Thrall identified the location of one of the bandit's famous escapades near the Crescenta Valley. The story starts in Montebello on April 15, 1874, when Vásquez and his gang descended on the Repetto Ranch. Repetto had just sold a flock of sheep, and Vásquez was hoping to liberate the profit from the rancher. Unfortunately for Vásquez, Repetto's cash was already in the bank in Los Angeles. Vásquez dispatched Repetto's young nephew to withdraw the money or his uncle would be killed. The terrified boy botched the withdrawal, the Los Angeles sheriff was alerted, and a posse set out for Repetto's. Vásquez spotted the

dust from the galloping posse, and his gang took off toward the Arroyo Seco. Even with the law in pursuit, the bold bandit stopped near the present-day Devil's Gate Dam to rob some Pasadena water company workers.

From there, he cut across La Cañada to the Soledad Road (now Angeles Crest Highway) that had been cut up the mountain just the year before. The winding wagon road climbed the San Gabriels as far as Dark Canyon, where it ended near the divide between the Arroyo Seco and Big Tujunga. Darkness overtook both Vásquez and the posse just behind him. It was a moonless night, and both the gang and the posse stopped until dawn. Vásquez said later that his camp that night was just seven hundred feet above the sheriff's posse, and he could have easily killed them all in the dark, but confident he would escape, he let them live.

When dawn broke, Vásquez and his gang went over the divide and straight down the mountainside into Big Tujunga Canyon. Their escape route is today called Vásquez Creek, near Grizzly Flat, just to the east of Mount Lukens. On the way down the nearly vertical slope, Vásquez's horse tumbled and broke a leg. Vásquez pulled the saddle off and continued down the slope on foot. At the bottom, he dropped his saddle and one of his pistols, hitched a ride with one of his gang and escaped out the canyon mouth near Tujunga.

From above, the sheriff and his posse watched the bandits ride down the vertical slope and realized they couldn't match their horsemanship. They turned around and raced back down the Soledad Road. At full gallop, they followed the road west across La Cañada, past where the Verdugo Hills Hospital is today and along Honolulu through the future Montrose. Up on what is now Briggs Terrace, new settler Theodore Pickens probably heard the hoofbeats and stuck his head out of his cabin to watch the dust trail of the posse as they galloped along Honolulu, up "Horse Thief Trail" and over the pass to Tujunga. But Vásquez had already escaped into the desolate San Fernando Valley.

Several years later, a Crescenta Valley resident found Vásquez's discarded saddle and pistol in the brush alongside Vásquez Creek. They were eventually donated to the Los Angeles County Museum of Natural History.

Vásquez's career came to an end in 1875. The governor offered an $8,000 reward for his capture, an enormous sum for that time. Sheriff William R. Rowland, who had nearly captured Vásquez on numerous occasions received information that the bandit was staying at the home of Greek George, whose home was located near today's Hollywood Bowl. George was a former camel driver from Fort Tejon. Vásquez was at lunch, unarmed and unaware, when he looked out the window and saw Rowland's posse. He leaped through a

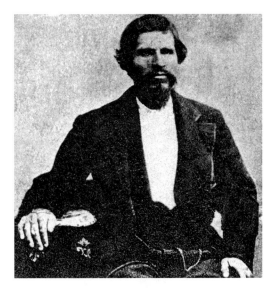

This oft-seen photo of Vasquez was taken in 1875, a year after his escape over the Angeles Crest and through Big Tujunga. The posed portrait was taken the day before his execution. It was hoped that the sales of the photo as an "execution souvenir" would help to pay Vasquez's defense lawyer. *Courtesy of the Glendale Public Library.*

window and was shot several times. He wisely surrendered. Vásquez said of his capture, "I was not expecting company at the time the arrest was made, or else the results may have been different." He was tried in San Jose for three murders. He was linked to nine killings. Hundreds came to visit him in his cell, and hundreds more attended his hanging. He appeared at all times to be polite and gentlemanly, and he died well on March 19, 1875.

Today, his fame lives on. Vásquez Rocks was considered to be one of his hideouts. Vásquez Rocks has been used in numerous movies, including *Gunga Din*, *The Charge of the Light Brigade* and *Blazing Saddles*, and such TV shows as *Law and Order*, *Gunsmoke*, *Bonanza* and *Star Trek*. The Santa Clarita school board voted unanimously to name its new high school in Agua Dulce after Vásquez. In Salinas, an elementary school in the Alisal Union School district followed Santa Clarita's lead. One must wonder about a community's standards when schools are named after a bandit and a murderer.

MURDER AT DEVIL'S GATE DAM, 1896

In March 1896, Tom Hall of Pasadena and a companion identified as a Mexican named Dolores were returning from a hunting trip. As they rode their horses to the bridge at Devil's Gate Dam, they saw two men fighting. One man fell, and the other man ran off with his dog. Hall stated that he

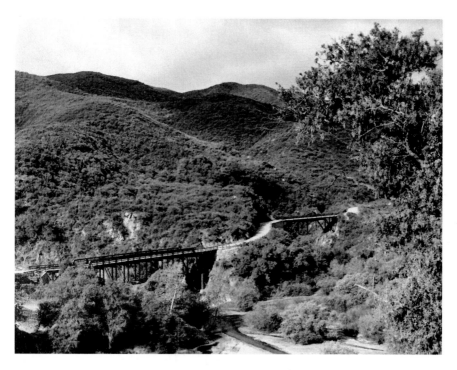

This turn-of-the-century view looking southwest down the Arroyo Seco shows the bridge connecting La Cañada to Pasadena at Devil's Gate. This is the area at which, in 1896, Tom Hall and his companion came upon the murder in progress. The bridge today is the site of the Devil's Gate Dam and the 210 Freeway overpass. The bridge pilings are still visible just inside the dam area. *Courtesy of the Glendale Public Library.*

did not get a good look at the man as he ran away, although he believed him to be a Mexican. Approaching the downed man, they discovered a Mexican dead from knife wounds to the back, breast and throat. They rode to a nearby Mexican camp for information. No one there spoke English. Hall and Dolores then rode to J.A. Vaigh's store and called Pasadena marshal Lacy. Marshal Lacy and the undertaker rode out and picked up the body.

Then came the trial in July under Judge Smith of department one of the superior court. The prosecutor, McComis, charged Manuel Lopez. The deceased was then identified as Jesús Alvarado. Manuel Lopez claimed his innocence. The prosecution presented as evidence a pair of bloody shears found at the murder scene. The shears were alleged to belong to Lopez. The defense asked for a continuance because of the absence of a witness. The judge asserted that the statement at the preliminary examination could be used instead. The jury was impaneled. The defense made the extraordinary suggestion that no witnesses be called and that the jury be read the entire

transcript after the preliminary examination. Equally extraordinary was that the prosecution agreed. This is an example of speedy justice handed out to Mexicans in nineteenth-century California courts. The preliminary testimony was read from 2:00 p.m. to 3:50 p.m. The prosecution rested. The defense asked the judge to dismiss the case on grounds of insufficient evidence. The judge refused, and the court was adjourned until the next day. The outcome of the trial is not known.

INDIAN MURDERED ON THE LA CAÑADA ROAD, 1896

In 1896, an Apache Indian from Arizona, Francisco Quijada, was tried for the murder of a local Indian by the name of José Maria Ochoa, who was killed on the La Cañada Road, presumably today's Verdugo Road in La Cañada. Both had worked as woodchoppers in the area. The body of the local Indian Ochoa had been found on the road with two knife wounds, one in the front and one in the back of the torso. There were signs of a struggle, blood was found on a tree limb nearby and the deceased man's hat and shirt were found some distance away. Several witnesses of Mexican and Indian descent were found in a woodchopper's camp nearby; they testified that the defendant Quijada had visited their camp briefly, alone and drunk, soon after the murder would have taken place. There were no witnesses to the murder, and the weapon was never found.

The defendant Quijada gave a long and rambling account of what had happened. He related that on the day of the alleged murder, he and Ochoa had visited a winery in La Cañada. While there, Ochoa found a piece of iron, sharpened on both ends, and stuck it into his belt, intending to make a knife of it later. Both men left the winery drunk and made their way down the road. At some point, Ochoa lay down, and when Quijada went to rouse him, he noticed blood on Ochoa's pants. The two drunk men got into a struggle, and Ochoa fell hard, facedown, apparently on the piece of iron he had in his belt. Quijada noticed the point of the piece of iron protruding through Ochoa's back, grabbed it and pulled it out through the man's body. Quijada said he didn't remember what he did with the iron. The defendant said he continued drinking, made his way back to the woodchopper's camp and continued to Pasadena. After a pursuit by the police, he was apprehended in a house in San Gabriel.

Although the evidence was circumstantial, the jury was perhaps swayed by the fact that Quijada had been in trouble twice before. He had gotten

WITH GREAT DISPATCH

Quijada to Be Imprisoned for Life

FOR MURDERING JOSE MARIA OCHOA

Defendant's Statement Wiped Out Hope

This is the headline of the article on Quijada's sentence in the *Los Angeles Herald* from Friday morning, October 30, 1896. "With Great Dispatch" describes the trial well, as it took less than a day to try, convict and sentence the Indian to life imprisonment on what was largely circumstantial evidence. *Courtesy of the* Los Angeles Times *Archives.*

into a fight in San Fernando and had resisted arrest afterward. Before that, he had been arrested for attempting to wreck a train by putting boulders on the track. In that case, he had been acquitted, as the only witness against him had been a jailhouse informant, a sheriff deputy posing as a prisoner.

The jury deliberated for just fifteen minutes and returned a verdict of guilty on the charge of first-degree murder. Quijada was sentenced to life in Folsom Prison.

THE CRESCENTA HOTEL DISASTER, 1887

In the late 1880s, La Crescenta founder Dr. Benjamin Brigg's dreams of establishing a town were coming together. He had built a schoolhouse, and in the spring of 1887, he convinced a couple real estate investors to build a hotel on the corner of Foothill Boulevard and Rosemont Avenue, where Fosters Donuts is today. It was two stories, built of wood and plaster on brick pillars and offering twenty-four furnished rooms. It was a growing business, as the curative powers of the valley's clean air gained a reputation among eastern health seekers. In December 1887, Edwin Arnold, along with his wife and two daughters, accepted the job of managing the Crescenta Hotel and attended to the fifteen guests staying there.

On December 14, a fierce Santa Ana windstorm had been blowing for three days. It should be remembered that in those days the valley floor had few trees, and with no windbreaks, the gusts were closer to the ground and more destructive. Many valley residents had abandoned their flimsy wood shacks and sheltered in the schoolhouse, which was made of cement.

Mr. Arnold was becoming increasingly worried about the stability of the hotel as it creaked and swayed with each gust. He went so far as to substitute candles for the kerosene lamps, which were more likely to cause a fire if the building were to fall. At midnight, he decided he'd be safer to seek shelter outside behind a big boulder and got his wife and kids out of bed. He opened the front door just as a big gust came, and that open door was the tipping point for the building's stability. There was a huge crash, the lights went out and Arnold was knocked unconscious. When he came to, he found himself trapped in a small opening in the rubble. Above the roar of the wind, he could hear others crying for help.

Those sheltering in the schoolhouse (the site of the library today) could see that there was now blackness where the lit windows of the hotel had been a few moments before and guessed the worst. They came running to the hotel with lanterns, only to be met with the sight of a demolished pile of wood and the cries of those trapped inside. They immediately began to dig into the rubble, following the sounds of voices. Arnold was freed and called out for his family, but he only heard his still trapped ten-year-old daughter crying, "Where are you, Daddy?" Another man was found still lying in his bed where timbers held him down. One gentleman had been blown or knocked out of a second-story window as the building came down and had landed on the ground outside unhurt. Mrs. Arnold was finally found with a beam across her neck, choked to death. Her three-year-old daughter was found crushed nearby.

The blame for the collapse fell squarely on the builder. The building had been built high but narrow, and the foundation was only thin brick pillars nine inches square spaced six to eight feet apart, unsuitable for strong wind. It's said that locals weren't surprised that it didn't survive the storm. A couple other buildings were blown down as well, and the ferocity of the windstorm probably shocked some newcomers. It created a mini exodus from the valley, with several families leaving permanently.

The Crescenta Hotel was rebuilt almost immediately, on a grander scale with three stories and thirty-two rooms. There was still a demand for clean Crescenta Valley air for easterners suffering from lung diseases. On Thanksgiving 1888, the new hotel hosted a party of fifty, and all agreed that "the place must seem a restful home-like retreat to the lone invalid seeking health among strange faces in our pure mountain air."

So some late night, when there's a Santa Ana blowing, if you're outside Fosters Donuts and you hear a strangled cry of "Where is my baby?" it might be the ghost of Mrs. Arnold, still trapped under a beam of the collapsed Crescenta Hotel.

Chinese Laundryman Murdered and Robbed, 1891

In 1891, a well-off Chinese man was murdered and robbed in La Cañada. Ah Sui ran a laundry business on the border of La Cañada and La Crescenta, around where the Glendale Freeway and the Foothill Freeway merge today. Ah Sui was found in his laundry with his throat cut and his money gone. The suspect was another Chinese man who had been seen in the area about the time of the murder.

Local historian Jo Anne Sadler relates that authorities did not pay much attention to crime in the Chinese community in Los Angeles. The fact that the above account was found in a Sacramento newspaper but was not covered in any Los Angeles papers attests to that. The Chinese community was basically ignored by local police, except for any bribes that could be solicited from Chinese organized-crime gangs (Tongs). In addition, Chinese people were afraid to testify against any other Chinese, for fear of retaliation by the Tongs. Thus, the murderer was probably never caught.

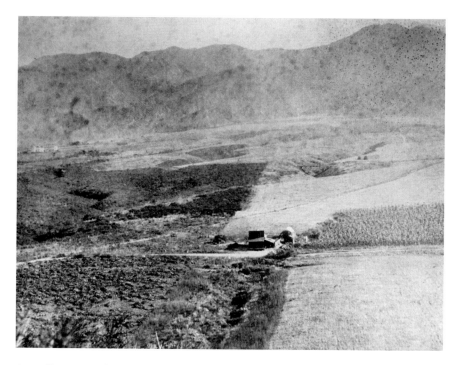

According to one pioneer's memories, this was the location of Ah Sui's laundry business, located on the road to La Cañada. The site today is a familiar one to local residents. It is now the location of the La Cañada United Artists Theater, and the photo was taken looking down from where the Verdugo Hills Hospital is today. *Courtesy of the Glendale Public Library.*

LA CRESCENTA AND CONSUMPTION

When we read the history of the Crescenta Valley, we often come across the term *consumption* as a disease or hear of some pioneer being called a consumptive. The very founding of La Crescenta was tied strongly to consumption. The city's founder, Dr. Benjamin Briggs, was driven by the disease—his wife died of it, and he eventually did as well—when he came to the valley to promote a cure for it.

Today, we know this disease as tuberculosis, but in the late 1800s, it was a mysterious illness that seemed to consume the victim's health and body, thus the name. In that period, it was epidemic in the United States. The numbers are shocking. Roughly one in five deaths were from consumption, and it was the leading cause of death. It's estimated that by the turn of the century, 80 percent of the population had been infected. Elusive to doctors of that time was the fact that the bacteria that caused the disease were airborne,

transmitted by saliva when a consumptive coughed or sneezed. There was no cure for the disease, and diagnosis of consumption was considered a death sentence.

And the death was a bad one. To doctors, the disease was erratic. Once a diagnosis of consumption was made, there was no way to know how the disease would progress. It could take months or years to die. It most often began with a dry cough and difficulty breathing. The cough would increase in intensity, exacerbated by ulcers in the throat and fevers. The consumptive would begin to waste away, tortured by painful joints. The death itself could be easy, with the victim's breath simply stopping. Or it could be very ugly, with the victim suffering a panicked feeling of suffocating, often accompanied by massive bleeding from the mouth and nose.

The only cure put forth by doctors of that time was dry, clean air. This prescription, combined with a prevalent fantasy of the West as an Eden of health and vigor, sent droves of "health seekers" scurrying westward to places like Arizona, Colorado, Southern California and the Crescenta Valley. Tens of thousands of invalids and consumptives streamed to the slopes of the San Gabriel Mountains, the so-called sanitarium belt, made up of hospitals, resorts, hotels and boardinghouses, all hoping to attract health seekers from the East. Cynically, intertwined with this was the promotion of real estate and the sales of railroad tickets. One promoter in particular was typical of that notion. Nathanial Carter was a consumptive who had come west to die but instead had regained his health and pegged it on our miraculous climate. He worked with the Southern Pacific Railroad Company to promote "invalid trains," using "before and after" photos of himself to promote ticket sales. He used his considerable profits to found the town of Sierra Madre, a community he designed to attract wealthy consumptives. Pasadena, too, was founded on this scheme, and claims of cures went to the ridiculous. One promoter wrote, "I thought I came here to die. When I left home I had but one lung and it was almost gone. I have been two weeks in Pasadena, have three lungs, can roar like a descending avalanche, ate three mules for breakfast, and am going to try it for another week."

All this promotion was taking place in the 1870s, and by 1881, when Dr. Benjamin Briggs bought land, this was already a successful formula. He did as other promoters and developers were doing: laid out a town site and advertised land sales in an area that promised healthful air and a vigorous lifestyle for health seekers. Along the way, he named his town Crescenta (the *La* was added later); established a school, church and hotel; planted trees; and attracted his wealthy friends and family to join him in this paradise.

There were several tubercular sanitariums located in the Crescenta Valley, and remnants of them still exist. Dunsmore Park on Dunsmore Avenue was a TB sanitarium from 1933 until 1956. The community building shown here was adapted from one of the sanitarium's hospital buildings, and the miles of whimsical stone and found-object walls of the park were built by the last owner of the sanitarium, perhaps using his patients for labor. *Photo by Mike Lawler.*

He had always intended to establish a hospital as well, but his own health problems killed him in 1893, before he could achieve that goal. However, he paved the way for other doctors to establish sanitariums based in the clean and healthful air of the Crescenta Valley, attracting health seekers for generations to come.

WOMAN CONVICTED OF MURDERING HUSBAND, THEN RELEASED, 1915

Mrs. Irene Murphy was accused of shooting her husband in the garden of their La Cañada home. The Murphys had moved to La Cañada in 1910 from Nevada. They had no children and seemed to be a happy couple. On April 15, their next-door neighbor, the Reverend T.L. Layne, heard a shot. He ran into his garden and looked next door. He saw Mr. Murphy on the ground,

and a few feet from his body lay a still smoking double-barreled shotgun. Mrs. Murphy was leaning against the kitchen door crying hysterically. Reverend Layne picked up the fatally wounded man. According to Layne, the dying Mr. Murphy accused his wife of shooting him. Dr. D.W. Hunt, a neighbor who lived a few doors down, was called to the scene. When he arrived, he found Mr. Murphy rapidly slipping away. The evidence indicated that the victim could not have caused his own death. He had powder burns on his chest, and both hands were shattered as if he had been warding off the final shot. Dr. Hunt stated that it had appeared to him that the blast had come from quite a distance away. When Mrs. Murphy was arrested, she insisted that she was innocent. She said that she and her husband were in the house "when they heard a cat scream in the yard. The cat had been a nuisance for quite some time, and Will decided to kill the cat. He loaded the gun and went to the backyard. I was behind him. He walked to the backyard dragging the gun behind him, the gun slipped from his hand, and as he turned to get it, the gun exploded. I don't remember anything after that." The evidence was deemed sufficient enough to charge Mrs. Murphy with murder. The body was taken to the Pullin Undertaking Rooms in Glendale.

On April 27, in county jail, Mrs. Murphy gave a more detailed account of what happened. She stated, "I did not kill Will. We have been together for seven years and were devoted to each other. Wherever he went, I went with him. I had warned him time and time again to be careful of that shotgun. He was very careless. I was in the house when I heard the shot. I ran outside to him. He wanted me to pick him up, but I couldn't. I went into the house to get a pillow; when I came out, Mr. Layne was there. I don't know how it happened; he must have leaned the gun against the porch and started to walk away when it slipped and fell." Mrs. Murphy stated that she had fired that gun once two months previously, which had laid her up for a week. The kick of the shotgun was just too much for a weak woman like herself.

She was represented by Chauncy Gardner and Edward Gilbert. Mrs. Murphy went to trial in Judge Willis's court in June 1915. She was found guilty and convicted of manslaughter. Although the case was purely circumstantial, it was presented in court by Deputy District Attorney Keetch in a convincing manner. Mrs. Murphy took the conviction hard and is believed to be the first woman in Los Angeles County to be convicted of manslaughter. One year after her conviction, Judge Houser reversed the verdict. Mrs. Murphy had been sentenced to one year in San

Quentin but had never left the Los Angeles County jail. Judge Houser held the evidence presented by the district attorney's office as insufficient for a conviction and ordered a new trial. The district attorney said there was no new evidence to present and moved for a dismissal of the charge. Mrs. Murphy was released.

A RACIALLY CHARGED MURDER IN WHITING WOODS, 1918

Whiting Woods, one of our most sedate neighborhoods, was the stage for perhaps Crescenta Valley's only racially charged murder. The story is given to us in an autobiography of Perry Whiting, founder of the Whiting-Mead Building Supply Company, still in business today. In 1918, Perry Whiting owned the eastern side of the canyon now known as Whiting Woods, which had a former combined bar and whorehouse on it, and had plans to acquire more land. He was still involved in his business activities elsewhere in the southland and so asked one of his trusted employees, John Allen, to come to Crescenta Valley to manage his property. The problem was that John Allen was black.

Crescenta Valley and Glendale were not models of racial harmony in those days. Just by way of example, it was in that era that the Ku Klux Klan held a rally in Glendale, marched down Brand Boulevard and burned a cross on the San Rafael Hills. Both areas actively enforced "racial covenants" that made it illegal for nonwhites to live there. Needless to say, the black John Allen had to walk a fine line.

Whiting rented the former bar and whorehouse to a restaurateur who operated it as the La Crescenta Lodge. Whether Whiting knew it or not, the restaurant soon became a speakeasy. As Allen was tasked with managing Whiting's affairs, he was thrust into the dirty politics of Prohibition. A frequent weekend guest of the speakeasy was the deputy district attorney, who took advantage of Allen. He sent him on errands to buy alcohol from local moonshiners, to ensure that there was a fully stocked bar at the canyon speakeasy.

Later, when the district attorney was under pressure to make some arrests of moonshiners, he knew right where to go for information: John Allen. He sent a sheriff to Crescenta Valley to find Allen. When the sheriff found him, he deputized him (without pay) and forced him to lead lawmen to the various local moonshiners from whom Allen had bought. Naturally, Allen

became a pariah. That very night, his house was burned down, and Allen began to fear for his life.

Jack Ronsie, an employee of the Crescenta Valley Water Company, was particularly vocal in his threats. Allen was really getting scared, so he borrowed a pistol from the district attorney. Allen was employed one evening at the roadhouse speakeasy, parking cars for the stream of guests that frequented the remote La Crescenta Lodge each night. That particular night, Jack Ronsie, a married man, was out with a pretty sixteen-year-old girl and, wanting to impress her, decided this was the night to confront Allen.

At 2:00 a.m., Ronsie and the girl pulled up to the roadhouse in a car, and Allen greeted them. Ronsie barked "Don't talk to me, you black n———" and climbed out of the car. "I'll fix you, you dirty black dog," said Ronsie and reached for his waistband. Allen, sure Ronsie was going to pull a gun, drew his own pistol and fired point-blank at the man. Ronsie fell but still appeared to be reaching for a gun, so Allen stood over him and shot him four more times. One report said that Ronsie crawled back into his car and ordered the young girl to get behind the wheel to get him to a doctor. That must have been a horrible scene, as the young girl had no idea how to drive a car. Ronsie quickly bled out on the seat next to her as she fumbled with the controls.

Allen turned himself in, but the community was in an uproar. A mob organized to lynch Allen, but the police responded quickly, cordoning off the jail with officers. At the inquest in Glendale, the room was packed with Ronsie's supporters, who whispered menacingly and guffawed loudly when Allen's name was mentioned. Another hundred men congregated outside, openly ridiculing the idea of a court trial for Allen. The handcuffed prisoner was hustled out a side door and down to county jail, where he was held without bail for his own protection. Harassment from the community continued at the trial, haters of Allen filling the courtroom and interrupting the proceedings with their outbursts, until the judge finally cleared the courtroom of spectators and placed guards outside.

There were plenty of witnesses to the murder, including the district attorney who had originated Allen's troubles in the first place. When he took the stand, the attorney maintained that Allen had fired the gun, which the district attorney had given him, in self-defense and that Ronsie had initiated the confrontation and had acted as though he was about to pull a weapon. But most witnesses blamed Allen. Here's the testimony of the sixteen-year-old girl who was with Ronsie: "The negro had spoken to Mr. Ronsie, but Mr. Ronsie refused to talk to him. Then the negro cursed

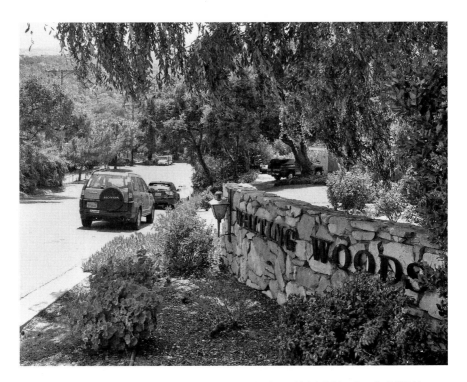

This is the view today standing at the entrance to the beautiful neighborhood of Whiting Woods. The roadhouse where the murder took place would have been located somewhere to the left side of the photo, closer to Mesa Lila Road. Perry Whiting later built his home on the other side of the canyon, on what is now Whiting Manor Lane. Whiting's property was subdivided in the 1950s and '60s. *Photo by Mike Lawler.*

him and shot him once. Mr. Ronsie fell to the ground. The negro stood over him, fired more shots at him as he lay on the ground. Then the negro laughed, put the gun in his pocket, and walked off with Mr. Burke [the district attorney]." Throughout the news articles about the trial, Ronsie is called Mr. Ronsie while Allen is consistently called "the negro."

Perry Whiting, who was Allen's employer at the time of the shooting, perhaps felt guilty for putting Allen in this difficult situation in the first place and used his influence to help get Allen's charges reduced to manslaughter. Allen was sentenced to ten years in San Quentin. There was much discussion in the community about revenge on Allen once he was released, but it was all for naught. Prison in that era was a dangerous place for a black man convicted of killing a white man, and Allen died in an "accident" before his sentence was up.

Chapter 2
1920s

Louise Peete, 1920
A Female Bluebeard

Louise Peete was born Lofie Louise Preslar on September 20, 1880, in Beinville, Louisiana. Wherever Louise appeared, it seemed death was sure to follow. The Preslar family was relatively wealthy, and Louise received the best education possible: "I came from cultured, educated people. My parents were not delinquents, and did not rear delinquent children." Louise attended one of the best private schools in New Orleans; however, she was expelled at the age of fifteen for her sexual escapades and for stealing jewelry from her classmates. Louise seemed constantly tempted to take other people's property, jewelry being at the top of her list. She was both beautiful and intelligent, qualities that she would exploit throughout her career. Louise married Henry Bosley in 1903, but he committed suicide shortly after finding her in bed with another man.

Louise sold Henry's possessions to finance her move to Shreveport, Louisiana, where she worked as a prostitute until she had accrued sufficient funds to move to Boston. In Boston, she introduced herself as Anna Lee Gould and used her education, social graces and beauty to her advantage. The twenty-year-old became a favorite of the local gentry. While she turned tricks for cash, she stole jewelry from the clients' wives. Run out of town by the Boston police, Louise made her way to Waco, Texas, and took up

residence with a local oilman Joseph Appel. She killed Appel one week after meeting him. Charged with murder, Louise was able to convince the jury that she had defended herself against an attempted rape. The jury accepted her defense and applauded their not guilty verdict. Interestingly enough, Louise did not explain what happened to Appel's jewelry.

In 1913, Louise married Harry Fauote, a hotel manager. Louise managed to steal $20,000 worth of jewelry from the hotel's safe. The police, unable to find any evidence, could not convict Louise. Harry found Louise in bed with another man. His reputation ruined, Fauote hanged himself in the hotel basement.

Louise then departed for Denver, where in 1914, she met Richard Peete. Their wedding was the big event of the social season. It seemed like a marriage made in heaven, especially when their blue-eyed daughter was born. The United States entered World War I, and Richard prospered. When peace was restored, Richard's business slumped, and he was threatened with bankruptcy. At this point, after six years of honesty, Louise decided that it was time to move on. "Going on a trip, my dear?" Richard asked. Louise responded, "I think I need a change of air, Richard, perhaps it would be better if I took a trip to Los Angeles. It will be better for the both of us."

In Los Angeles, Louise signed on with Jacob C. Denton as housekeeper and lover. After weeks of torrid sex, Louise asked Denton to marry her. He refused—a fatal mistake. Denton was reported missing on May 30, 1920. Louise continued to live in Denton's home for two months. She then

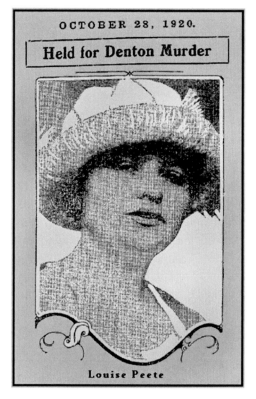

OCTOBER 28, 1920.

Held for Denton Murder

Louise Peete

A news photo of Louise Peete in 1920 shows her as an aging beauty. She would have been forty at this time. The photo was taken during the period when she was being held by police at the La Crescenta Hotel. *Courtesy of the* Los Angeles Times *Archives.*

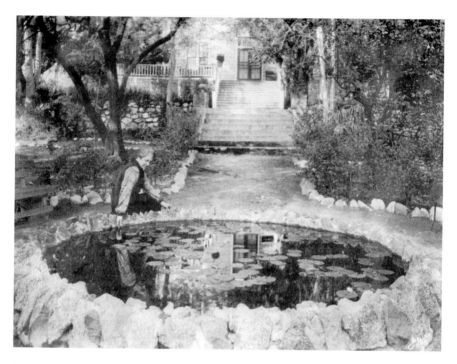

The murderous Louise Peete was held under house arrest at the grand old La Crescenta Hotel but escaped right under the noses of the four detectives assigned to guard her. The hotel was located at the intersection of Foothill Boulevard and Rosemont Street. This fishpond at the hotel's entrance is about where Fosters Donuts is today, and the wide entry steps behind would be where Starbuck's Coffee is located. *Photo courtesy of Eugene Zimmer.*

left to reconcile with her husband in Denver. Denton's body was found under the floor of his own house on September 23, 1920.

Mrs. R.C. Peete was accused of the murder of J.C. Denton of Los Angeles. She proclaimed her innocence and voluntarily returned from Denver, with her invalid husband and four-year-old daughter. The police stopped her train early at the El Cajon Pass, just north of San Bernardino, and arrested her. Mrs. Peete would accuse the district attorney of kidnapping her. Her attorney, O.N. Hilton, said that they would ask Judge Jackson to charge District Attorney Doran with kidnapping. Hilton claimed that Mrs. Peete was held under house arrest at the La Crescenta Hotel without a warrant and against her will. The grand hotel stood at the northwest corner of Foothill Boulevard and Rosemont Avenue. Its guests included Ian Paderwski, pianist and future president of Poland. Other guests were Colonel Samuel Merrill, former consul to India, and Lawrence Tibbitt, the famed opera star. The hotel was the social center of the community.

The district attorney would charge Mrs. Peete with murdering J.C. Denton and burying his body in the basement of his fourteen-room mansion at 675 South Catalina Street, Los Angeles. The district attorney claimed that Mrs. Peete continued to live in the house for two months, while Denton's body decomposed beneath her. Mrs. Peete repeatedly professed her innocence and claimed that Doran was out to crucify her.

During the investigation, Mrs. Peete spoke of a mysterious Spanish woman whom Denton had shot and wounded. It was this mysterious woman and an unidentified man who killed Denton, according to Louise. The Boston police came into the case with evidence that Mrs. Peete, known to them as a Louise M. Gould, was actually Mrs. R.H. Rosley of Dallas. According to the Boston police, in 1911, Mrs. Peete had posed as a rich nineteen-year-old heiress. She claimed to have been placed in a convent in Los Angeles from which she had escaped. She also claimed that she owned property in Norway and Germany. Because of her charm and beauty, she was accepted by many of the most prominent families in Boston. One family had taken her in and treated her as a daughter. She proceeded to run up large bills in some of the leading stores in Boston. When her fraud was discovered, she was allowed to peacefully leave to avoid further embarrassment to Boston's high society.

During the investigation, Mrs. Peete escaped from the La Crescenta Hotel while under guard of four Los Angeles detectives. Mrs. Peete voluntarily returned and stated that she had just needed a little quiet time. She was indicted, convicted, judged insane and sentenced to life imprisonment. She was spared the death penalty by an all-male jury.

So far there are two suicides arguably caused by and two men murdered by Louise. She received a life sentence, and her career should have been over. However, Louise's most productive years were yet to come. While serving her life sentence, Louise's cellmate, Constance Renner, attempted suicide. Her third husband R.C. Peete committed suicide in a cheap motel. Because of Louise's sweetness, charming demeanor and time spent as a model prisoner, she was paroled on April 11, 1939, after serving only eighteen years. She was fifty-nine years old.

Louise was paroled into the custody of Jesse Marcy, who had helped Louise to gain her freedom. Marcy died shortly after Louise began to work for her. Marcy's death was ruled to be of "natural causes." In addition, one of Louise's elderly co-workers also died at this time under suspicious circumstances. Louise then worked for Emily D. Latham, who also had helped Louise secure her freedom. Latham died of injuries related to a fall.

You might ask how it was that the Los Angeles Police Department did not look at Louise more closely. At the time of her parole, she had legally changed her name to Anna Lee. The police, in a case of criminal negligence, did not do a background check on Anna. Therefore, her explanation of accidental deaths was accepted.

The next unfortunates to take in Louise were the Lathams, Arthur and his wife, Margaret (not related to Emily D. Latham, previously mentioned). Louise married her third husband at this time, Lee Bordon Judson, who was sixty-seven. Louise had been hired to help care for Arthur Latham, who was mentally ill. Soon after this, Mrs. Latham disappeared. When Judson asked Louise where Margaret Latham was, she told him that Arthur had bitten Margaret's nose, and the woman had gone away for plastic surgery. Louise and Judson continued to live in the house and use the Lathams' assets as their own. Louise got rid of Arthur by having him committed to Patton State Hospital in San Bernardino. He died there six months later, believing that his wife had abandoned him. Louise donated his body to a medical school.

Louise's remarkable career was drawing to a close. The bank detected her forgeries, and police found Margaret's body in a shallow grave outside the kitchen window. Louise claimed that Arthur had killed his wife. She had not reported the murder fearing that suspicion would fall on her due to her background. Lee Judson was cleared of any wrongdoing. Upon his release, he immediately jumped off a twelve-story building. This time, a jury of eleven

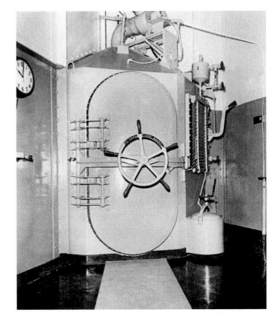

This is the entrance to the gas chamber at San Quentin State Prison. This view would have been one of Louise Peete's last sights as she was led to her execution in 1947. At that time, cyanide gas was used to kill prisoners. From 1937 to 1995, 196 prisoners, including Mrs. Peete, were executed here. *Courtesy of murderpedia.org.*

women sentenced Louise to the gas chamber. All of her appeals failed, but to the last day, she didn't believe that she would be executed. She stated that Governor Earl Warren was a gentleman and that a gentleman would never execute a woman. She was wrong—dead wrong. She was executed on April 10, 1947. She was the second woman to be executed in the state of California. To date, there have been only four women in executed in California.

HE SAID, SHE SAID IN LA CRESCENTA ATTACK, 1923

According to the *Los Angeles Times*, in June 1923, John Howard, fifty, was arrested for assaulting Adeline Simmons in La Crescenta. According to both parties, Howard had lived at the home of Mr. and Mrs. Simmons in Los Angeles for about two years and had entered into several real estate partnerships with the husband and wife. One morning, Mrs. Simmons took a car ride with Howard to Crescenta Valley, presumably to view some property. Once reaching La Crescenta in the car, their two stories began to diverge.

According to Mrs. Simmons, as they drove along, Howard suddenly pulled out a pocket knife and slashed at her several times, inflicting wounds. He stopped the car and threw her out onto the ground. He got out, dragged her to some nearby bushes and began slashing her again with the knife. After she pleaded for her life, he stopped the attack and put her back in the car. He drove her back to Los Angeles to the home of Simpson's friend Mrs. Wissel, where she collapsed. A doctor was summoned, and he declared Simpson to be in serious condition. The police arrested John Howard and charged him with intent to commit murder.

Howard, in a statement to the arresting officers, told a different story. He said that during their car ride in La Crescenta, Simpson suddenly leaped from the moving car. Her foot caught on the car's running board, and she fell onto some rocks, cutting herself up. When he stopped the car to help her, she attacked him, but he fended her off. He got her back in the car, but when he tried to take her back to the Simmons home, she refused to get out of the car. She demanded to be taken to her friend's house. He dropped her off there. He said he was unaware of her accusations until he was arrested.

On doctor's orders, Mrs. Simmons was kept isolated at the Wissel home for several days because of "nervous shock" from her injuries. Howard was arraigned, and his bail was set at $5,000. He was unable to make bail and was held in county jail. There were no further articles about the outcome of the trial.

Mysterious Dead Body Found by Hiker, 1924

A hiker from Los Angeles who had come to the Crescenta Valley to sample the hiking trails and glorious views stumbled across a dead body in the foothills below the San Gabriel Mountains in September 1924. The remains, badly decomposed after having lain in the summer heat for at least a month, were found several hundred yards off the trail and miles from any dwelling or roadway.

Papers on the body identified the man as a resident of New Orleans, and he was wearing a ring from a New Orleans Masonic Temple. He had train tickets on his person that showed he had arrived in Los Angeles one year previous and had been living in that city since then. A bank statement showed that he had opened an account at a bank in Montrose a few months before.

The police suspected foul play for several reasons. The dead man had no reason to be in that remote area, as he was not dressed for hiking. Although the body was too decomposed to be sure, the police noted that the head seemed at an unusual angle and that there appeared to be marks around the neck. The body had been found lying out flat on its back, indicating it had been placed there, rather than having fallen there, and there was no sign of a struggle. No suicide note was found.

The Rattlesnake Bite That Killed the Rich Man's Son, 1926

Harvey Bissell was without doubt the most prominent resident of the Crescenta Valley in the 1910s and '20s. In the '10s, he came to the Crescenta Valley with his wife and started his family, eventually having two sons and a daughter. Harvey was the grandson of the founder of the Bissell Manufacturing Company of Grand Rapids, Michigan, who made a fortune with the introduction of the Bissell Carpet Sweeper in the late 1800s. Bissell Inc. still thrives today with a full line of cleaning products, most notably the Bissell Vacuum Cleaner line.

The Bissell property, which is now the Pinecrest neighborhood at the top of La Crescenta Avenue, has a long and interesting history. One of the very early ranches in the valley, it was above the property developed into La Crescenta by Dr. Benjamin Briggs. It had been owned in the 1880s by John Shields, for which Shields Canyon was named, and then by

This photo of the Crescenta Valley was taken from the Verdugo Mountains looking north in about 1916. The diagonal street running up from the bottom of the photo is La Crescenta Avenue. The cleared area of Harvey Bissell's Hi-Up Ranch can be seen at the top of La Crescenta Avenue, hard up against the San Gabriel Mountains. *Courtesy of the Glendale Public Library.*

Colonel Samuel Merrill, a high-ranking diplomat and friend to President Benjamin Harrison. He appropriately named the ranch Granite Heights. In the 1910s, the property was purchased by Harvey Bissell. He renamed the property the Hi-Up Ranch and built a veritable paradise as his personal playground, with groves of trees and gardens, walking paths and stables for his Thoroughbred horses.

Harvey Bissell, despite his vast wealth, was a man of the people, and he dove head first into community service. One of Bissell's pet projects was the Angeles Forest Protective Association, which focused on forest conservation and firefighting. Bissell provided the first fire engine for the valley, and the bell to summon the volunteer firefighters was located on the Bissell ranch. He funded forestry research projects such as the Grizzly Flats Experimental Forest on the backside of Mount Lukens. He was a leader in the Kiwanis

Club and many other civic groups. It was said by a contemporary in the valley that he was the "answer to all things" in La Crescenta. Needless to say he was well loved by the locals.

But neither his popularity nor his wealth could save him and his family from personal misfortune. In 1925, they lost their daughter to diphtheria, and just a few months later, in 1926, the family, still reeling from the loss, was visited with a second tragedy.

The Bissell mansion was located on a terrace at the end of what is today Fiero Way, a small cul-de-sac branching to the east at the very top of La Crescenta Avenue. Being right up against the San Gabriel Mountains, the Hi-Up Ranch was visited by all sorts of dangerous wildlife, including coyotes, mountain lions and rattlesnakes. One day at noon, while Harvey Bissell was in Los Angeles on business, the elder of the two remaining sons, four-year-old James Bissell, was playing in the backyard when he stepped directly in front of a large rattler. The big snake reared back and struck the boy on the leg. His screams attracted the attention of Mrs. Bissell, who loaded him into the family car for the long ride straight down the hill to the office of Dr. Wemple, a large brick building on the corner of La Crescenta and Honolulu Avenues in Verdugo City. First aid was given to the boy, and he was transported to the Glendale Research Hospital. Harvey Bissell used his influence to summon the best doctors available, but the amount of venom injected into the small boy was too much. After a valiant eleven-hour battle at the Glendale hospital, James Bissell died at midnight.

The Bissell family moved away from the valley in the 1930s with their remaining son, who later went on to head the Bissell Company.

Boys Playing with a Loaded Gun, 1926

On August 31, 1926, two boys, one age eleven and the other age fourteen, were playing with a loaded shotgun in the 2700 block of Prospect Avenue. The eleven-year-old boy swung the gun up to fire it into the air, but it went off before he had it fully raised. The edge of the shot spread caught the fourteen-year-old in the head, and a number of pellets lodged in the boy's scalp—a minor wound. They were some distance apart when the gun went off, and had they been any closer, the shot would have killed or seriously wounded the boy.

BRAWL AT THE BABY CHRISTENING, 1928

In 1928, in the "Mexican quarter" of La Cañada, a baby christening was the cause for a celebration. As the celebrants got increasingly drunk, a fight broke out, which soon became an all-out brawl with fists, rocks and knives. It was quickly broken up by sheriff deputies from both Montrose and Altadena. Five injured Mexicans were sent to the criminal ward of General Hospital, two with knife wounds. One of them, a wound in the back, was quite serious. After an investigation, one man was arrested for the knifings.

PAUL McCARTON, EAGLE SCOUT, SHOT BY A FRIEND, 1928

In 1924, the McCarton family moved to Montrose and into a cozy little house at the intersection of Orangedale and Mira Vista, directly across from a small triangle of land in the center of the intersection that served as a park for the neighborhood. Twelve-year-old Paul McCarton immediately joined Troop 2 of the local Boy Scouts, and his father A.P. McCarton, filled leadership roles in the scout organization. Paul blossomed under the guidance of the Boy Scouts, and as he moved up the ranks in the scouts, he showed evidence of his good nature and his natural leadership ability. He was elected president of his Sunday school class and became the leader of the Montrose Boy Scout Band. The local American Legion recognized his promise as a good citizen and presented him with a gold watch fob as an award at its Citizenship Day ceremonies. At only fifteen, he achieved the rank of Eagle Scout, the youngest Eagle Scout in the valley. Paul was named senior patrol leader of Troop 2 and had completed the scoutmaster training in preparation for further leadership roles in scouting.

A couple months after Paul's sixteenth birthday in September 1928, the McCarton family went on vacation, taking Paul's friend Robert Dixon with them. They stayed in a small miner's cabin near Gold Lake in the northern Sierras above Lake Tahoe. The boys were having a wonderful adventure, hiking the trails of what is today the Plumas National Forest.

On September 6, the two boys were especially excited after spotting bear tracks while on an afternoon hike. That night, after the family had dinner in the little cabin, Paul left the table and went outside into the dark night for more adventure. A few moments later, Paul's friend Robert also left the cabin, hoping to catch up with him. On the way out the door, perhaps

thinking of the bear tracks he had seen that afternoon, Robert grabbed a .22 rifle to take with him. Robert didn't realize that Paul was hiding just outside the cabin behind a fallen tree. When Paul jumped out from behind the tree in the dark, he scared Robert, who had the rifle in his hands. The gun went off, and the bullet went in Paul's mouth and through his spinal cord, killing him instantly. The McCartons drove Paul's body to Portola, twenty-seven miles away, where a coroner's inquest was held, ruling the death accidental and exonerating Robert.

Paul McCarton's funeral was huge, and the outpouring of sympathy and grief from the community was overwhelming. A long funeral procession wound through the streets of Glendale to Forest Lawn, with one hundred Boy Scouts acting as bodyguards to the casket. The funeral was held at the Little Church of the Flowers, and indeed, the church was filled to overflowing with flowers given by the community. Scouts from Glendale, Burbank and Eagle Rock attended the service. Paul's brother Eagle Scouts gathered around the casket, draped with the Boy Scout flag, and recited the Great Scoutmaster's prayer. On the hill above the church, the Glendale Boy Scout Bugle Corps played taps. After the service, Paul's body was cremated and interred in the Victory plot in Forest Lawn. The flowers that had filled the church were transported to Children's Hospital in Los Angeles.

Paul McCarton's grief-stricken parents returned to their home in Montrose, where they memorialized Paul in the little triangle park at Orangedale and Mira Vista directly across from their house. They planted a deodar tree in his honor and put in a park bench with a plaque commemorating their son. Over the years, the tree grew to full height, but

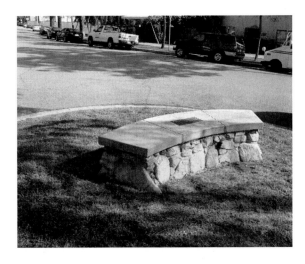

This pretty little stone bench was built in 2006 to memorialize Paul McCarton, a popular young Eagle Scout who died accidently at age sixteen in 1928. The bench is located in a small triangle park in the middle of the intersection of Orangedale and Mira Vista Avenues. *Photo by Mike Lawler.*

the bench and the plaque at some point disappeared. The memory of Paul McCarton seemed destined to be lost forever.

In the early 2000s, local historian Art Cobery was reading through some old newspapers and came across the story of Paul McCarton. He was intrigued and then fascinated with this tragic story, and he began to formulate plans to resurrect McCarton's memory. In 2006, with the help of the Historical Society of the Crescenta Valley, the County of Los Angeles and members of the neighborhood surrounding the triangle park, a new bench was constructed of local stone where the old bench had been. Boy Scouts from Troop 317 provided the labor. A bronze plaque was installed to forever keep alive the memory of Paul McCarton, Eagle Scout.

Daughter Jilted So Aged Father Beats Boyfriend to Death, 1928

In October 1928, Pedro Martinez, longtime section foreman for the Glendale and Montrose Railway, was living with Mary Carmona in a little railroad-owned house in the 2500 block of Montrose Avenue. Unfortunately for Mary, Pedro decided to try another girlfriend and jilted her. She went home to her father, but she returned soon after and beat Pedro severely with a table leg. Mary's father, Frank Carmona, seventy-three, decided to show his daughter how to do the job right and showed up at Pedro's house a few weeks later with a buddy. Pedro was found by the Montrose sheriffs, dead, his head beaten in and missing $600. Frank Carmona was apprehended nearby, his clothes spattered with blood. A few days later, an eleven-year-old boy, who lived near the murder site on Montrose Avenue, was playing in a vacant lot and found a heavy lead pipe covered in dried blood. It was believed that the pipe was the weapon used to murder Martinez.

Chapter 3

1930s

Joseph Ardizzone, Mafia Boss, 1930

Joseph "Ironman" Ardizzone was born Giuseppe Ernesto on November 19, 1844, in Palermo, Italy. He was an early Los Angeles mobster, a successful rancher, farmer and restaurant owner. His home was at 10949 West Mount Gleason, Sunland, currently the home of Mount Gleason Middle School.

According to Mary Lee Tiernan, a local historian, Joe was a bootlegger, and his farm was riddled with secret tunnels and escape routes. During Prohibition, he had three cellars for secret storage of wine. When the Mount Gleason school was being built, the tractors kept falling into the tunnels, so Joe's son was contacted and asked to mark out the tunnels to avoid further accidents. Joseph Ardizzone had a long-standing feud with another mafia family, the Matrangas. Joe killed George Maisano, a member of the Matrangas family. He claimed it was in self-defense, but he fled the state to avoid retaliation. On his return to California, he was arrested, but the charges were later dropped. Shortly after this incident, his house mysteriously burned down.

In the 1920s, Joe was the treasurer of the Italian Protection League, and Jack Dragna was the president. Jack had come to America from Corleone, Sicily, in 1908. Jack was supposedly in the business of importing bananas but was actually the head of the mafia in Los Angeles. Ardizonne took over control of the mafia from Jack Dragna. The details of Ardizzone's mafia dealings are somewhat sketchy, but it is known that he traveled to Chicago

and New York to meet Al Capone and other syndicate bosses. It is also known that Joe boasted of having killed thirty men. He was considered a good father and husband but ran a strict household. He treated his family, friends and neighbors well. He was very generous. His wife, Elsie, dressed in the finest clothes and jewelry. He entertained judges, senators, governors and law enforcement officials. These guests often gave ten-dollar gold coins to the Ardizzone children, Tony and Josephine. The family frequently dined with John McGroarty, journalist, congressman and poet laureate of the state of California. Joe helped movie stars, including Rudolph Valentino.

Every year, Joe and the family took a three-week vacation to Venice Beach. They sometimes entertained as many as thirty friends and relatives. The men visited the gambling ships off Long Beach. Joe and Elsie gambled on horse and dog races. Things began to go bad for Joe in 1931, when he tried to expand his territory. In February 1931, Joe attempted to kidnap a rival by the name of Jimmy Basile. Jimmy's friends tried to stop the kidnapping in Downey and opened fire on Joe's car. Jimmy was killed, and Joe was

Mount Gleason Middle School, on Mount Gleason Avenue in Tujunga, is the former site of mafia boss Joseph Ardizzone's ranch. In the '20s, Ardizzone was a bootlegger, and his property was riddled with underground chambers, secret tunnels and escape routes. These unrecorded and treacherous tunnels provided nasty surprises for workers grading the property for construction of the junior high. *Photo by Mike Lawler.*

wounded. While in recovery at the hospital, a second attempt was made on Joe's life. The family acted as bodyguards.

Joe decided to retire in October 1931. But his rivals did not trust Joe's retirement and decided to ensure it. Joe left home on October 15, 1931, for a short trip and never returned. No trace of him was ever found. He was probably killed by members of his own crime family. He was forty-six years old. Jack Dragna resumed control of the mafia. Joe's wife lost the farm but held on to the family's restaurant at Foothill and Mount Gleason. Elsie died in 1987.

THE MURDER OF MOTLEY FLINT, 1930

The Julian Oil Scandal of the 1920s as detailed by Jules Tygiel in his book *The Great LA Swindle* was a massive crime. Approximately $150 million was stolen from investors in Los Angeles. Tens of thousands of elderly widows and children had their economic security and retirements destroyed. Not one victim recovered a nickel of his lost investment.

Frank Keaton was one of those ruined in the scandal. He blamed the Julian collapse for all his losses. His wife described him as insane after the stock market crash of 1929. Motley Flint became the scapegoat for his failed dreams. Motley and his brother, Frank Flint, were born in Massachusetts and raised in San Francisco. They came to Los Angeles in the land boom of the 1880s and became active in local Republican politics. Motley joined the Elks and Shriners and became known as the best lodge man in America. Frank was a U.S. senator between 1905 and 1911. He was a creation of the Southern Pacific Railroad. He was successful in business law and founded Flintridge, an exclusive community built into a hillside near JPL resembling a Greek Mediterranean village. Motley was described as the dominant of the two brothers. He was considered charismatic. He was Los Angeles postmaster, president of the Metropolitan Bank and Trust, director of the First National Bank and president of Los Angeles County Relief. He earned a reputation for helping the poor and unemployed. He liked to consider himself as a Santa Claus for the less fortunate of Los Angeles.

The Julian Oil Scandal was a confidence game. It consisted of two overlapping crimes. The scandal was fictionalized in Upton Sinclair's book *Oil* and was later adapted into the Academy Award–winning film *There Will Be Blood*. The scandal took place shortly after the Teapot Dome and Elk Hills

oil scandals. These were the biggest scandals of the Harding administration. Those scandals involved two other Californians, one of whom was a resident of La Cañada. Harry F. Sinclair lived at 3972 Alta Vista Drive in a ten-thousand-square-foot, two-story, twenty-room house with five bedroom suites and nine bathrooms. The home had a hand-painted ceiling. Sinclair owned at one time two professional baseball teams in the Federal League. The Federal League lasted two seasons, from 1913 to 1915. Sinclair would go to jail for seven months for stealing $100 million worth of oil. Sinclair, I am sure, considered it a good day's work—seven months for $100 million. He died in 1956 at age eighty.

The first crime was an over issue of stock. The company sold 3,614 percent of the company. The second was the creation of an investment pool, known as the millionaire's pool. This pool guaranteed substantial profits to its members. The members included Motley Flint, Louis B. Mayer, Cecil B. DeMille and Harry Halderman, grandfather of H.R. Halderman. These men earned a 75 percent profit while forty thousand folks lost their life savings. One result of the scandal was the election of John Porter as mayor of Los Angeles. Porter was a former Klansman. Despite the magnitude of the crime, there were almost no convictions of anyone involved in the scandal. During the trial, there were charges of jury tampering and a proven case of the district attorney, Asa Keyes, taking bribes. Keyes did go to San Quentin. As district attorney, Keyes sent 4,030 men and women to prison in just five years.

Frustration over the inability to achieve anything remotely like justice led to three bullets being fired into Motley's home on Los Feliz. The end came for Motley in 1930. He was under indictment for the violation of the corporate securities act. He had just finished testifying, and as he walked out of the courtroom, Frank Keaton fired three bullets into his body. The first shot shattered his neck and lodged in his collarbone, the second in his heart and the third in his liver and lungs. He was dead before he hit the floor. Warner Brothers flew its flags at half-mast in honor of Motley's early support of the movie industry. He left the bulk of his estate as gifts for poor children and for the assistance of the elderly and destitute. When Keaton was apprehended, they found ten cents on him. Motley's body had $63,000 in cash.

Dead Old Woman, 1930

Murder or Accident?

On August 13, 1930, Barbara Doyle, a seventy-year-old widow, was found dead in her home at 347 East Greely Street in Tujunga. It was reported that three masked nightriders were seen near her home immediately after the "murder." Mr. and Mrs. Ned Bradford of La Crescenta told police that three masked white men had attempted to stop their automobile as they returned from Hollywood. The Bradfords drove past these men. They testified that the men appeared to have blood on their clothes and hands. The police were unable to find any trace of the three masked men, and Captain Bright of the homicide detail offered another theory for the death of Mrs. Doyle. Captain Bright stated that at first appearance, it looked as though Mrs. Doyle had been felled by an assassin who crushed her skull with a bludgeon. However, it is possible she died after a bad fall. After conferring with the autopsy surgeon, Captain Bright felt Mrs. Doyle might have fractured her head in a heavy fall. The bloodstains on the wall could have been caused by her staggering about dazed by her injuries. Her neighbor C.A. Kelly was initially considered a suspect. Kelly and Mrs. Doyle had had an argument, and she had filed a complaint against him. The investigation determined his innocence. Mrs. Doyle's body was found on the sleeping porch of her home.

Robbery Gone Incredibly Bad, 1931

Earnest Carroseo, twenty-seven, of 2241½ Paulma Street, Los Angeles, was in General Hospital after being shot by a woman he attempted to hold up in La Cañada. Carroseo and José Cruz were attempting to rob a store at 4390 Indiana Street in La Cañada. Mr. and Mrs. Charles Powers were the managers of the store. Mr. Powers fought with Carroseo, who pulled the trigger of the gun four times while it was pressed against Powers's body, but the gun misfired each time. The gun, with hammer marks on four unexploded shells, was found outside the store. When Carroseo attempted to flee, Mrs. Anna May Powers fired a bullet, breaking Carroseo's left leg. All in all, it was a very lucky day for Charles Powers but not so good for Earnest Carroseo.

SUICIDE PLEA FOR HELP RECEIVED TOO LATE, 1932

In July 1932, a man in Los Angeles received a letter from his lifelong friend in La Crescenta. The letter, opened late, asked him to come to his house "on very important business" on the previous night. The man was concerned because his friend had been seriously ill for the previous two years. He rushed to his friend's home in the 2600 block of Pickens Street and found the friend's lifeless body in the bathroom. He had committed suicide by firing a .25-caliber bullet through his abdomen and opening the natural gas valves in the house.

RELIGIOUS NUT MURDERS DAUGHTER, 1933

Mrs. Marie Kennedy, thirty-six, living in the 2300 block of Montrose Avenue, Montrose, California, murdered her eight-year-old daughter in an attempt to save her daughter's soul from damnation. Mrs. Kennedy, believing she had been ordained to save her daughter's soul, drowned her in the bathtub. She then attempted to electrocute herself. The effort failed due to a weak current, and she received only a mild shock. Mrs. Kennedy then called the Red Cross and explained what she had done, asking that an ambulance be sent to pick up her daughter's body. The Red Cross notified police, who sent Constable Harris of Montrose to the Kennedy home. He found Mrs. Kennedy bending over the nude body of her little girl. The girl had been placed in front of a lighted gas heater in an attempt to revive her. Mrs. Kennedy was hysterical. In killing her daughter, she had hoped to save her from damnation. She felt she had killed her on the wrong day and, therefore, not saved her soul after all. Mrs. Kennedy said her daughter had begged her to go to school because it was Valentine's Day. Mrs. M.L. Kennedy, of 2250 Montrose Avenue, the girl's grandmother, said her daughter-in-law had been acting queerly for some time and had become a religious fanatic. Police investigated the mother, who repeatedly made references to the Aum Center, a local religious group. Mrs. Kennedy often expressed the view that the "forces of the damned" were after her girl. The Monday before the murder, the grandmother said Mrs. Kennedy had come to her home and acted as if Jane, the daughter, was there. "I intended to kill her this morning" the mother said, "but she ran away. I'm looking for her now." The grandmother informed her son Herbert of the threat to his daughter.

He took no action; he said his wife appeared to be all right when he left for work, and he thought the threat had passed. Mrs. Kennedy was booked at county jail on charges of murder and placed in a women's jail hospital under observation by Benjamin Black, the jail physician.

Fire and Flood, November 1933 to January 1, 1934

The New Years Eve flood has been covered extensively in other works, notably by Art Cobery. The hillside fire of 1933 has not. The San Gabriel Mountains were burning above La Cañada and La Crescenta. The fires east of Pickens Canyon threatened the Gould Castle. The castle was saved; its olive groves were not. Backfires were set between Pickens and Earl Canyons. In La Crescenta, much of Harvey Bissell's Hi-Up Ranch was burned, and the L'Hermitage Mountain Vineyard lost a building, a garage, twenty thousand gallons of wine and fifteen hundred gallons of brandy. Homes were lost on both New York Drive and Briggs Terrace. The fire denuded the foothills, setting up the disaster to come. After weeks of steady rain, at midnight on New Year's Eve, there was a cloudburst. It generated a wall of water twenty feet high. The flood destroyed hundreds of home and took at least thirty-eight lives. The true toll will never be known, as according to local lore, there were many homeless people living in the canyons due to the Depression.

Death Once Stalked Our American Legion Hall, 1934

The Verdugo Hills Memorial Hall located at 4011 La Crescenta Avenue serves as the home for local American Legion Post 288 and the Veterans of Foreign Wars. It also hosts church groups, exercise classes and Boy Scout meetings. But unbeknown to most, this hall was the site of swift and powerful violence that took the lives of at least twelve men, women and children and injured many more. Perhaps the word *Memorial* in the hall's title should give us a clue that the quiet Legion Hall was once a death trap.

Here's the recently rediscovered story. In the 1920s, the Crescenta Valley was booming, and hundreds, including many World War I veterans, moved here to take advantage of our beautiful climate. An American Legion Hall was built on the northeast corner of Rosemont and Fairway Avenues to serve

the growing town, as both a home for newly formed Legion Post 288 and as a community center. In October 1925, the Crescenta Valley celebrated its dedication with huge fanfare and speeches by dignitaries. It served the community faithfully for nearly a decade, no one knowing that it had been built in the destructive path of the geologically regular flash floods that swept the valley a couple times each century.

A quick geology lesson: the soil of the Crescenta Valley is composed of layer after layer of alluvial fan. The San Gabriel Mountains are some of the fastest-growing mountains in the world. They are made of brittle, decomposing granite, which fractures with each earthquake like safety glass. All those chunks of granite fall down into the canyons, along with the sand from the decomposing rocks. When it rains hard, those chunks of rock and sand are carried out across the valley, fanning out from the canyon mouths; thus the term "alluvial fan" and our notoriously rocky soil.

In a rainstorm, the faster the water comes down the mountain, the more rocks it can carry. Freshly burned and denuded mountains ensure that the water, with no foliage and roots to slow its downhill flow, will be moving very fast by the time it reaches the rock-filled canyons. A little water in the canyons carries mud, the water being strong enough to push only fine grains of sand. As the volume of water increases, it is capable of moving larger objects, moving from small rocks to larger rocks to boulders.

It's at this point where we find the fundamental difference between a "mudflow" and a "debris flow." As the amount of particulates increase in the flow of water, along with an increase in speed, there comes a tipping point at which the physics of the flow changes completely. The larger rocks begin to "float" on the material below it, allowing them to pick up speed and, in some cases, surf the front of the flow. This creates a churning wall of mud and boulders that can move quite fast, at thirty, forty or fifty miles per hour.

The mass, which geologists call a "slug," can't be stopped by anything man-made, which is why, in photos of the '34 flood, you see bare foundations from which houses were sheared off, as though by a gigantic bulldozer. The debris flow turns back into a mudflow only when it slows down enough for the rocks to drop out, while the mud and water continue on.

In late 1933, a destructive fire had cleared the front range of the San Gabriel Mountains of vegetation, and heavy rains through December generated mudflows. By December 31, the Legion Hall had been set up as a Red Cross evacuation center for those whose homes had been flooded. American Legion Auxiliary members Myrtle Adams and Dr. Vera Kahn

were in charge as dozens of refugees crowded into the hall, and the word went out across the valley to head to the Legion Hall for safety.

At midnight on New Years Eve 1934, a huge cloudburst hit the rain-soaked hillsides above our valley. As described previously, the water from the strong rainstorm ran off the denuded mountainsides very quickly. When the fast-moving water hit the accumulated rocks and sand in the canyon bottoms, the whole mass—rocks, sand, mud and water—cut loose and roared down the canyons. The twenty-foot-high debris flow and slurry of mud and rocks, with massive boulders being pushed in front, flew down Pickens Canyon at a tremendous speed, crossed Foothill Boulevard and tore through the populated areas above the Legion Hall.

Inside the Legion Hall, the refugees could hear and feel the debris slug bearing down on them. The sound was described to be like the sound of an approaching locomotive, and the ground shook like an earthquake. They must have known something horrible was headed their way, as someone was heard screaming into a telephone receiver, "Mayday! Mayday! Mayday!" The huge debris flow roared past the building and just clipped the back corner of the hall, knocking in the back wall. The interior of the hall filled quickly with a mud and rock mixture, all of it moving fast and swirling. One witness saw a piano get pushed across the room and crush a man against the wall. Those near the front door were pushed out by the rocks and water. A man standing on the front porch heard the destruction coming toward the door behind him, and he made a superhuman leap off the porch into a nearby tree, saving himself. The woman who had stood next to him on the porch was engulfed by the torrent pouring out the front door and killed. Those still inside were no doubt being pummeled by the rocks and drowned by the mud and water.

After a second or two, the floor could no longer support the great weight of the flood, and a portion of it near the front gave way. The mud and rocks that had come in the back wall now rushed out the hole in the front, and the building emptied in a heartbeat, taking out everyone and everything inside. Photos of the interior taken the next day show the room intact but completely empty, every stick of furniture having been sucked out along with its human occupants. At least twelve of the refugees, including Mrs. Adams and Dr. Kahn, were dead, and scores were injured. Overall, the flood killed about thirty-eight people and left hundreds homeless.

Crescenta Valley was a place of great resilience back then, and the community immediately started rebuilding, including making plans for a

The front of the American Legion Hall on January 1, 1934, the morning after the flood. This is where the torrent of mud and rocks exited the building, sweeping the victim's bodies away with it. From the stone porch, one man was able to leap into the tree to the right just before the flood burst through the front door. The woman standing on the porch next to him was carried away and killed. *Courtesy of Joe and Linda Rakasits.*

new American Legion Hall. The Bonetto family, who lived on Manhattan Avenue near La Crescenta Avenue, donated land for a new hall, and by July, steam shovels began excavating the new site.

The old Legion Hall on Rosemont, although it had a big hole in both the front and back, was still standing. It being the Great Depression, money and materials were tight. The decision was made to reuse the building, so the holes in the front and back were patched up. The basically intact structure was jacked up off its foundation and set down on wheels. A *Los Angeles Times* photo from August 1934 shows the intact building being towed down Montrose Avenue by a pitifully small truck. It was set in place on its new basement foundation on La Crescenta Avenue in a reversed position, with the old front of the hall facing the rear of the property, and twelve feet of new building was added on the street side, which is now used as the foyer and offices. The labor and materials to finish the building were donated by the community, and the hall was rededicated as a memorial to Mrs. Adams and Dr. Kahn.

A community eager to put a tragic past behind it quickly forgot that this was the same building that had once been the site of a deadly natural

A 1934 view, looking east from the mud- and rock-buried intersection of Rosemont and Fairway Avenues. The main flow swept downhill to one side of the American Legion Hall, but a portion clipped the back corner and flowed through the hall, exiting through the front. Although the majority of fatalities came from the hall, the building was structurally intact. *Courtesy of the Historical Society of the Crescenta Valley.*

The American Legion Hall was relatively undamaged. Rather than demolish it, the hall was simply moved to a safer location at La Crescenta and Manhattan Avenues. This is the same angle as the previous photo. Note that the former front of the hall is now the back, and that twelve feet were added on the street side to accommodate an entry lobby. *Photo by Mike Lawler.*

Today, the site of the tragedy is now a memorial garden at Fairway and Rosemont Avenues, with a rock cairn and plaque. A home was built over the foundations of the Legion Hall. The tree that the man jumped into from the porch of the hall is still there and can be seen on the right side of the photo. *Photo by Mike Lawler.*

disaster. It hosts Boy Scout meetings, exercise classes and facilities for churchless religious congregations. Few, if any, remember its deadly legacy, and for decades, no one has considered the ghosts of those who died there.

THE RATTLESNAKE MURDER, 1935

The murder of Mrs. Mary Busch James, twenty-eight, a resident in the 1300 block of Verdugo Road, had everything. It involved torture, sex, drugs and greed. The murder weapons were black widow spiders, rattlesnakes and a backyard fishpond.

On August 4, 1935, Mary James's body was found facedown in the pond behind her house. Her husband, Robert James, thirty-eight, and two neighbors discovered the body. The death was initially ruled accidental until Mr. James began to vigorously push to collect on three separate life insurance policies. The three policies had a double indemnity clause and were worth about $10,000 all together.

The Jameses had been married only about three months, and only one payment had been made on the policies. Robert James's actions interested the police, and they began a prolonged investigation. The investigation hit pay dirt in May, when Charles H. Hope, a thirty-seven-year-old ex-sailor, accused Robert James of murder. The case unraveled because Hope's conscience got the better of him. He told a friend of the murder. The friend informed the police. Hope stated that James offered to split the insurance money with him if he would procure the murder weapons. Hope said that they considered several options in their plan to murder Mrs. James. One idea was to stage a robbery gone wrong in which Mrs. James was murdered. A second option was to burn down the house with Mrs. James inside. They thought of dumping black widow spiders in her bed while she slept and went so far as to procure the black widows before abandoning the plan. Hope was then instructed to buy rattlesnakes for the murder. He purchased two rattlesnakes named Lethal and Lightning from a man named "Snakey Joe" in Pasadena for ten cents a pound. He delivered them to James in specially constructed glass-covered boxes. Mrs. James was pregnant, and Robert had convinced her to have an abortion. Since abortion was illegal in 1935, the procedure had to be kept secret. She was told that because the abortion was illegal, she could not know her abortionist. Mrs. James was drugged and tied to the kitchen table. Her eyes and mouth were taped shut. Hope posed as the abortionist. Hope then stated that James thrust his wife's left leg into the box of rattlesnakes. The snakes had been purchased for their known viciousness. Hope stated that his wife, Florence, waited in the car while the murder was taking place. He repeatedly claimed that his wife knew nothing of the murder. After the snakes had bitten Mrs. James, Hope and his wife left the scene of the murder. However, Hope returned later that evening to the James home. Mr. James came out of the house and told Hope that his wife was not yet dead. James returned to the house and again came out to the car stating that he had just drowned her. He then had Hope help him carry the body out to the fishpond. After the murder, Hope was given a bucket of wet clothes and blankets and told to dispose of them.

Told of Hope's confession, James denied that he had anything to do with his wife's death. Police took James to the house next door, where he was held prisoner for the next forty-eight hours. There was no indictment, no arrest warrant and no defense attorney present. The police interrogated James in shifts. They never allowed him any rest. He never admitted to the murder. At the end of the interrogation, he was arrested on three counts of incest with

his niece Lois Wright. He would later be convicted on the incest charges and sentenced to fifty years in prison.

The next day, James was subjected to nine hours of interrogation. He was denied food and rest during this time. Finally, James asked to be allowed to eat. He said he would confess if he were allowed to eat: "You feed me and I will tell you what you want to know." At dinner, James made incriminating statements: "If you convict me of this murder, I won't squawk." Deputy Sheriff's Killion and Grey asked, "Is that because you know you murdered Mary?" James replied, "I had just as well say that I did as that I didn't." His confession was completed at 3:00 a.m. Mrs. James's body was exhumed and was found to contain rattlesnake venom.

As interesting as all this was, much more was soon discovered. James was born Major Raymond Lisenba in 1885. He had been married five times. His first wife divorced him due to sadism and perverted sexual practices. He deserted his second wife after getting her pregnant. His third wife, Ninoma Wallace, drowned in her bathtub while recovering from a car accident. Ninoma had extensive head wounds from the accident. James, however, was uninjured in the accident. He claims to have jumped from the car before it went off the road and down the hill. The police were suspicious, as a bloody hammer was found in the car. James was also somehow miraculously clean after jumping from the car. Ninoma could remember nothing about the accident. It was while recovering from the accident at a secluded location that Ninoma drowned. James collected $14,000 on Ninoma's insurance policy, on which only one payment had been made. James bought a new Pierce-Arrow convertible and a new wardrobe. He drove to Alabama to show the family how well he was doing. James's sister and brother-in-law had saved him from a life of poverty by paying his way through barber college. James repaid them by seducing their eighteen-year-old daughter, Lois Wright. He moved with her to Los Angeles. He employed her as a manicurist in his barbershop. In Los Angeles, James remarried once again. He had the marriage annulled when wife number four refused to get a physical exam for a life insurance policy (which was probably good thinking on her part).

While looking for wife number five, James took out a $5,000 life insurance policy on his nephew, who then mysteriously died in an automobile accident. James had telegraphed Mrs. Little Liseba of Birmingham that both nephew and niece had been killed in a car crash, but he jumped the gun and appeared to be "prophetic," as the telegram was sent two weeks before the accident. James had previously tried to take out a life insurance policy on his niece, Lois Wright. When Lois

learned of her uncle's actions she said, "My God, I knew nothing of this. It is too horrible to think about. I guess I am a lucky girl."

James and Hope were convicted of the murder of the last Mrs. James in September 1936, after a two-month trial. Judge Fricke imposed a sentence of death by hanging on James and life in prison for Hope. James's attorneys, Russell E. Parsons and William Clarke, sought a new trial on the basis of misconduct on the part of the district attorney. They claimed that the district attorney's actions in taking the two rattlesnakes into the courtroom had prejudiced the jury, especially since one of the rattlesnakes got loose in the courtroom. Judge Fricke denied a new trial. The California Supreme Court upheld the conviction. This case was appealed to the U.S. Supreme Court. It was La Cañada's first Supreme Court case. The case was *Lisemba v. People of the State of California 1941*. James's attorneys held that he deserved a new trial because he was held for twenty-four hours, slapped and deprived of sleep and food until a confession was made. The decision of the court was seven to two against James. Felix Frankfurter, later rated a great justice of the Supreme Court, and Jimmy Burns, rated a failed justice, were part of the majority vote. When James was told of the Supreme Court's decision, he said, "I can take it. Let's just say that rattlesnake Bob James is not afraid to die." James underwent a prison conversion and said that his belief in the Bible made it easier to face his end. Finally, after the U.S. Supreme Court turned down another of James's appeals and Governor Olson rejected his appeal for clemency, Robert S. James was hanged on May 1, 1942—six years and seven months after the death of his wife of three months. He was the last man put to death by hanging in California. California had changed the method of execution to the gas chamber by 1942. However, the judge held that James had been sentenced to hang, and hang he did.

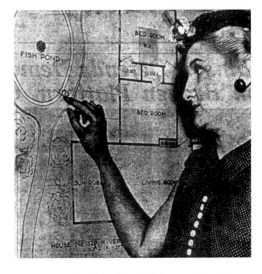

A witness in the "Rattlesnake" James trial points out on a map the fishpond where Mrs. James's body was found. When Robert James found that his pregnant wife wouldn't die after being bitten by rattlesnakes, he dragged her into the yard and held her head under water in the fishpond outside their home. *Courtesy of the* Los Angeles Times *Archives.*

EX-WIFE KILLS HUSBAND IN FRONT OF YOUNG SON, 1938

At her trial, a dramatically weeping Dorothy Donegan is comforted by her father. She had pleaded insanity after shooting her husband in front of her ten-year-old son. The court wasn't buying it and found her sane—and guilty. *Courtesy of the* Los Angeles Times *Archives.*

On July 2, 1938, Mrs. Dorothy Donegan, forty-one, of the 5500 block of Freeman Street in La Crescenta was arrested after admitting to killing her ex-husband. Mrs. Donegan drove to 2546 North Willard Street in San Gabriel to take possession of her ten-year-old son, Arthur. She entered the home of William W. Donegan, forty-one, a WPA worker. She found him reading a bedtime story to Arthur. Mrs. Donegan motioned to Arthur to come to her. When he did, Mrs. Donegan shot William. Mrs. Donegan's first shot missed, and William attempted to escape and was subsequently shot in the chest. This wound by itself would have proved fatal, but William staggered into the kitchen and collapsed as Mrs. Donegan fired three additional shots into his body. The couple's seventeen-year-old daughter, Cecilia, was asleep in the house when the murder took place.

The Donegans had been married eighteen years and divorced for two and a half. In recent weeks, the Donegans had been quarreling. She had him arrested for assault and battery. He had her arrested for disturbing the peace. Mrs. Donegan had purchased the gun from a pawnshop on Main Street in Glendale two weeks before the murder. Mrs. Donegan was tried in the superior court with Judge Frank M. Smith presiding. Mrs. Donegan used an insanity defense. She testified that she had gone to William's home to visit her children. She said that she did not remember the shooting, saying her mind went blank after her former

husband grabbed her by the throat during a scuffle. Mrs. Donegan's alienist (a psychiatrist) Dr. Ross Moore expressed the opinion that Mrs. Donegan was insane at the time of the shooting. Alienists for the prosecution testified to the opposite. She was found sane and guilty of second-degree murder. She faced jail time of five years to life.

HUSBAND SHOOTS FLEEING WIFE, 1938

Glen Elmore, thirty-two, of Long Beach, was arrested on July 29, 1938, and charged with the murder of his wife, Irene Belle Elmore, twenty-eight. Glen Elmore denied that he had any intent to kill his wife. He claimed that the gun accidentally discharged when he fought with his father-in-law, Robert L. Johnson. Elmore claimed that he only wanted to scare his wife into returning to him. Johnson told police that Elmore had come to his house demanding to see his wife. Johnson informed him that she was probably in La Crescenta. The two men drove to a house in the 2300 block of Olive Street, La Crescenta, the home of F.L. Sherwood. There they were met by Louisa Belle Gorman, Mrs. Elmore's sister-in-law. Glen Elmore promised her that he would make no trouble. Once inside the house, he hurled Louisa Gorman into the kitchen. According to Johnson, Elmore lunged into the bedroom, weapon in hand and had sworn at Irene Elmore. He shouted at her, "Run away from me now!" Irene started up from the bed. Elmore pointed the gun and fired twice. The first bullet struck her in the wrist and the second, in the chest. Johnson and Elmore then fought for the gun. When Elmore lost the gun, he ran out of the house saying that he was going to kill himself. Deputy sheriffs captured Elmore in the woodshed. He said that it was all a terrible mistake and that he only wanted his wife back. Glen Elmore and his wife had lived together for seven years and had only married recently in Riverside, California. He stated that his wife had left him fifteen times in seven years, but they had always reconciled. The Elmores had been arrested on morals charges in Signal Hill on March 14, 1936, and sentenced to six months in jail. Mrs. Elmore left behind her father, mother, two sons from a previous marriage and two stepbrothers. One stepbrother was an outfielder for the Milwaukee Brewers, and the other stepbrother was an outfielder for the Philadelphia Athletics. Glen Elmore was sentenced to San Quentin for five years to life by superior court judge A.A. Scott. The judge said that Elmore was lucky to have escaped the gas chamber. Judge Scott stated that he personally felt Elmore was guilty of first-degree murder.

Airplane Crash on Pennsylvania Avenue, 1939

Because Los Angeles has been one of the greatest centers of aircraft development, the Crescenta Valley has been used many times as an emergency landing strip for those often-unreliable early airplanes.

In 1939, two Army Air Corps reserve officers took off in a two-seat training plane from Long Beach Airport and headed for the San Gabriel Mountains. Lieutenant Colonel Kenneth Decker and Lieutenant Theodore Steiner had been airborne about three hours, and Crescenta Valley residents saw them circling the valley several times. No one knows exactly what went wrong, but it appeared to witnesses that they tried to land on Pennsylvania Avenue heading uphill. They perhaps caught a wingtip on the ground or maybe hit a wire or clipped a pole, but they careened off Pennsylvania to the west near where the freeway crosses today. The spinning wreckage missed several homes before finally coming to rest in the backyard of 3146 Encinal, the site now underneath the westbound Pennsylvania offramp. A poorly reproduced *Ledger* photo from 1939 shows the aircraft completely wadded up. The pilots Decker and Steiner had been both been killed on impact, but there had been no fire, perhaps indicating that the plane's ignition was off or that the switch had been turned off as they tried to land. It was midday and so was witnessed by many in the valley, including a group of boys playing on the football field of what is now Crescenta Valley High School. One of that group, Bob Crowe, told me about this crash.

An interesting closing postscript to this tragedy is that in 1978, the *Glendale News Press* did an article on the beautiful and unusual walls at Dunsmore Park. The retaining walls of that park are similar to the Watts Towers in that they are a fantastic assemblage of colored stones and minerals from all over the United States, along with car parts and kitchen utensils arranged into whimsical designs. They were created by an eccentric local, Milton Hofert, in a ten-year period between the mid-1940s and mid-'50s. Hofert then handed over the land to Glendale for use as a park. In the 1978 article describing the stone and junk folk art incased in the miles of walls in Dunsmore Park, they wrote of a hand-made plaque Hofert had placed in one wall. He had inscribed, "In memory of Lt. Col. Kenneth Decker, US Army Air Corps, crashed—La Crescenta, Dec. 10, 1939," and around the words were arranged uniform insignia, uniform buttons, cuff links and a small gold airplane. Sadly, that plaque is no longer in the park, and it was probably pried out, as many of Hofert's "artworks" have been for their souvenir value. Yet another lost treasure of our valley.

RED JENSEN, 1939

The Child Psycho Killer of La Crescenta

Back in the 1930s, the Jensen family of La Crescenta had big problems with their son Richard, nicknamed "Red" because of his mop of curly red hair. The kid had a penchant for thievery and, starting at six years old, began a steady stream of burglaries and vandalism. Often caught at it, he was sent to various reform schools and homes for delinquents. Each time he was released, he'd begin his crimes again, so nonchalantly that he'd even leave thank-you notes behind: "Thanks for the stuff," written in a childlike scrawl. By his preteens, he was doing hard time in the crowded and brutal Whittier State School for Delinquents, spending much of his time in solitary confinement.

In the summer of 1939, at the age of fourteen, he was released back to his parents. For two months, he seemed reformed—until, that is, thirteen-year-old Billy Williams next door called him an "ex-con."

On a hot August 22, Mrs. Jensen heard a whining noise that she thought was the neighbor's dog. She called out to Red, who was down in his basement "play-room," "What's wrong with that dog?" Red replied oddly, "He's got some tacks in his mouth." When the whining turned into louder yowling coming from where Red was, Red's mother tried the door handle to the playroom and found it locked. "Don't come in here," Red called, but Mrs. Jensen demanded he open the door. He did, just a crack, and Mrs. Williams could see his face was splattered with blood. "I just killed Billy Williams," Red muttered. Mrs. Jensen screamed, and Red pushed past her and ran. Billy Williams lay inside, dead, his skull crushed with a hammer, a copper wire twisted around his neck and stab wounds to his torso.

The police caught up with Red the next day, all the way down in Venice. He told investigators, "Nah, I ain't sorry. I just pegged him when the guy called me an ex-con. He got what was coming to him." They later found a hole dug in the backyard where Red had planned to cut up and bury the body.

Red Jensen was too young for the death penalty, but they had to do something with him. He even told a reporter, "I'm the kind of guy who should be put away for life." He was simply warehoused in the prison system for a decade or so. For those who think that the justice system is more lax today than it was then, in 1952, despite a murder conviction, three escape attempts and a history of prison troublemaking, Red Jensen was declared no longer a menace and granted "supervised leaves." He almost immediately went on a killing spree.

He rigged up an elaborate "automotive murder machine" in his car. Mounting a gun in the back seat facing the passenger seat, he rigged a wire from the trigger to a spot he could reach under the driver's seat. He went cruising for victims. He nailed his first one, a sixteen-year-old hitchhiker who seemingly vanished and was discovered only after Red later confessed. His second victim, a marine hitchhiking in the San Fernando area, was luckier. The remotely fired bullet struck one of the springs of the seat back and whacked the marine in the back. Stunned, he staggered out of the car, where Red attacked him with hammer blows to the head, stole his clothes and, before leaving, finished him off with a shotgun blast to the chest. Marines, though, are tough, and this one regained consciousness and crawled

A magazine compilation of photos from the 1939 trial of Red Jensen. In the main photo, he looks pensive for the camera, displaying his boyish good looks and curly red hair. In the lower photo, he coldly demonstrates for the court how he finished off thirteen-year-old Billy Williams with hammer blows, after strangling and stabbing him. *Courtesy of watchingrobertpickton88015.yuku.com.*

bloody and naked for a mile to a residence, where he was discovered. He survived to testify at Red's trial.

Red again was matter-of-fact and cold about his crimes, and this time, there was no question about what to do with him. He was put to death in San Quentin's gas chamber on February 11, 1955.

Somewhere in La Crescenta, there's a little house with a basement that still looks just as it did in 1939, its occupants unaware of the coldblooded murder that happened there. Even in our peaceful neighborhoods, there's a history of evil.

AUTO "ACCIDENT" KILLS FAMILY AT MOUNT WILSON, 1939

In 1939, a man and his family were involved in a tragic auto accident on Mount Wilson Road. The man told investigators that his brakes had gone out on the way down the winding, steep road and that he had just managed to open his door and roll out before the car plunged off the road for a thousand-foot drop, killing all four members of his family in the car. Further investigation revealed that the man had just taken out a $40,000 life insurance policy on his family. When the bodies were recovered, an autopsy found that they all had mysterious marks on their foreheads. The driver was arrested on suspicion of murder.

Chapter 4
1940s

THE TOUCHING AND TRAGIC STORY OF THE ZWICK FAMILY, 1943

As shoppers walk along the 2300 block of Honolulu Avenue in Montrose, they pass many businesses whose names carry a history—the City Hall Coffee Shop, the Montrose Bowl, Al's Italian Deli—and all have a story worth telling. But perhaps the most engaging story of all is that of Zwick's Plaza, a cozy Spanish-style retail and office complex just across the street from the bowling alley.

The Zwicks built a house for their little family—mom, dad and their two toddler boys, Charles and Leland—in the early 1920s on Honolulu Avenue, near the bustling block-long business district of Montrose, when the 2300 block was still residential. In the early '30s, the family moved briefly to Hollywood to run a grocery store. While there, little Charles Zwick took a shot at fame by knocking on the door of Hal Roach's nearby home and brazenly asked to be cast in the *Our Gang* comedies. Roach agreed to the brave boy's request, and the two Zwick boys were inserted into a few of the classic slapstick comedies. There is a famous, often-seen production photo of Charles Zwick with his face half black from the open end of a stovepipe, while Leland Zwick, Spanky McFarland, Farina Hoskins and the rest of the *Our Gang* players look on.

The Zwicks came back to their home in Montrose, and Charles and Leland continued in the Crescenta Valley schools. Both boys were interested in aviation and took flying lessons. When World War II broke

out, both boys, already pilots, joined the army air corps and were assigned to teach flying to pilot-trainees.

Right after they joined up, Charles married a girl from La Crescenta, and she followed him to Lomita Flight Strip (now Torrance Airport). She tells the story that he secretly took her up in his P-38, once over the Crescenta Valley and another time when they flew south along the coast. On that flight, the P-38 they were in had just been repaired and had no radio equipment. They were deemed "unidentified" by ground anti-aircraft batteries, and the searchlights stabbed through the dark trying to find them. They're lucky they didn't get shot at.

The Lomita Flight Strip, near Torrance, California, was a training base, and Charles and Leland were tasked with teaching recruits the basics of flying and the art of handling the sometimes-treacherous twin-engine Lockheed Lightning fighter (P-38). One Saturday morning in October 1943, Charles and Leland were to lead two formations of P-38

This is the courtyard of Zwick Plaza, 2331 Honolulu Avenue in Montrose. It's the former site of the Zwick family's home, and the retail and office building was named for them by the developer in the 1970s. To the left, on the wall of the stairwell, is a plaque memorializing the Zwick brothers, and to the right is the small fountain where the boys' handprints are enshrined. *Photo by Mike Lawler.*

trainees, Charles in the first group and Leland leading the second. As they walked out to the strip, Leland asked Charles how he liked the plane assigned to him. Charles answered that he didn't like it, and so Leland laughingly traded planes with him. As they took off, Leland was now in the lead plane (the one Charles didn't like), and Charles was leading the second flight. As the first formation lifted off the runway, one engine on Leland's plane cut out, and he rolled over and crashed before his brother's horrified eyes. He was killed instantly. Just one month later, in November, Charles was instructing a student in aerobatics in a two-seat Vultee Trainer when they lost control and crashed in Palos Verdes. Both Zwick boys were now dead.

After making the biggest sacrifice parents can make, the Zwicks lived on in quiet dignity in their little house in Montrose. When Mrs. Zwick finally died in the 1970s, she left the house to Charles's widow, who in

When the Zwicks built their house in 1923, Mr. Zwick had his two sons put their handprints in the wet cement of their patio, where they remained for half a century. When contractor John Bluff, a friend of the Zwick family, demolished the house in the '70s, he saved this treasure and placed it beneath the courtyard fountain. It reads, "CCZ (Charles C. Zwick), LCZ (Leland C. Zwick), 1-25-23." *Photo by Mike Lawler.*

turn sold it to local builder John Bluff, who had often aided the aged Mrs. Zwick in her waning years. He developed the very tasteful little office and retail building where the Zwick house had been and dedicated it to them, naming it Zwick's Plaza. As a beautiful tribute to the Zwick brothers, Bluff carefully lifted a section of concrete from the Zwick's old house that had the boys' handprints in it and lovingly placed it in front of the fountain in the courtyard of Zwick's Plaza.

Next time you're in Montrose, please stop by Zwick's Plaza. As you enter the courtyard, read the plaque on the left side that describes some of the story I've told you here. Then walk to the fountain and find the little chunk of cement, nearly ninety years old now. Touch the two small fading handprints, and feel the power of this tragic story.

BEULAH OVERELL, 1947

Lust and Money

In La Cañada-Flintridge, on Los Robles Avenue, sits an eight-thousand-square-foot art deco estate. The home was built in 1929 at a cost of $600,000. This was at a time when homes on Orange Grove in Pasadena were selling in the $300,000 range. The home sits on a 1.2-acre estate. This site also harbors a story made, at least, for a TV movie. According to Brooke W. Wilson in *The Newport Harbor Murders: Revisited*, the Overells were important members of the community. Walter had made a fortune in furniture and real estate. He and his wife, Beulah, were murdered when their forty-seven-foot cabin cruiser, the *Mary E*, blew up in Newport Harbor in 1947. Suspicion fell on their daughter, Beulah Louise, and her World War II veteran boyfriend, "Bud" Gollum. The murder became a big-time sensation similar to the O.J. Simpson trial. The case had all the necessary ingredients: murder; lust; passionate, perverted sex; and greed. Prominent people were involved, including U.S. senator Frank P. Flint, who was reportedly having an affair with Mrs. Overell. Flint was a notorious womanizer. He named Beulah Street after her. The daughter, Beulah Louise, was a seventeen-year-old student at the University of Southern California (USC). She was described as headstrong, spoiled rotten and liked by very few. The parents threw a birthday party for Beulah Louise to which no one was willing to come. Her mother had been

forced to pay guests to attend. Beulah Louise had informed her parents of her intent to marry her naval hero, the only man to have shown an interest in this homely and lonely girl. The parents considered this a poor match for their daughter and threatened to disown her. But Beulah Louise told them she intended to marry Gollum on April 30, 1947, when she would be eighteen years of age. Mr. and Mrs. Overell, Beulah Louise and Gollum were on board the yacht in Newport Harbor. Bud and Beulah left the boat for a late-night dinner. While they were gone, a time bomb attached to thirty sticks of dynamite exploded. The explosion was so powerful that "it just about blew me out of my bunk," stated retired Los Angeles firefighter F.E. Moore. His boat had been moored seventy-five feet away. The day after the explosion, Beulah Louise and Gollum were arrested and charged with murder. According to the coroner, Mrs. Overell had not died in the explosion, and Walter's death was not due to the plank that impaled him. Mrs. Overell and Walter had died an hour before the explosion due to multiple skull fractures caused by a ball-peen hammer.

During the investigation, the prosecution gathered together what was considered a bulletproof case. Gollum had purchased fifty sticks of dynamite from a Chatsworth company, Trojan Powder, the day before the explosion. A receipt for the explosives was found in Gollum's camera case. He had signed the receipt with a different name. In Gollum's car, pieces of wire and adhesive tape, similar to the ones used in the bomb, were found. Bloody clothes were also found in the car. Gollum told the police that Walter had asked him to buy the dynamite to remove tree stumps. The police cited Beulah Louise's lack of emotion over her parents' deaths as suspicious. She stood to inherit $600,000 to $1 million. She wore her mother's mink coat upon her arrival at the jail. In jail, the couple wrote lurid love letters to each other. Complete copies of the original letters are contained in Wilson's book. They are detailed and too graphic to quote here. They are also too juvenile and banal to be interesting. Gollum wrote, "Because I love and adore and worship and cherish you with all my heart, I will kidnap and carry you off somewhere where no one will ever be able to find us. I will make passionate and violent love to you. If you ever marry another person, I will kill him." Beulah Louise wrote back, "My darling, oh my pops, popsy, darling, my beautiful handsome intelligent pops, I adore you always and eternally." The prosecution said that the couple enjoyed an explicit, perverted, sadistic, sexual passion.

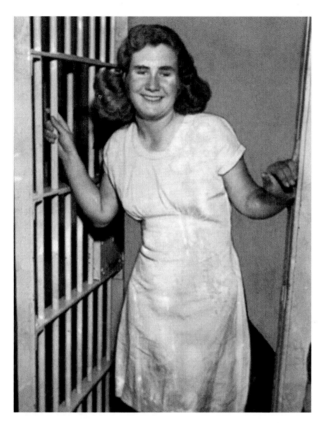

During a trial as sensational as anything seen up to that time, there was no better way to commemorate the occasion than with a glamour shot of seventeen-year-old Beulah Overell in her prison frock. While in jail awaiting trial, Beulah and her lover and co-conspirator exchanged explicit love letters. The lurid trial was a national sensation and considered the trial of the century. *Courtesy of murderpedia.org.*

The trial, at the time, was considered the crime of the century. It was broadcast over KVOE Santa Ana. It took four weeks to empanel a jury. The court had to wade through a pool of five hundred potential jurors to find twelve who would be impartial. The trial lasted four and a half months. It was the longest trial in U.S. history up to that time. The defense attorney, Otto Jacobs, destroyed the prosecution's case. He claimed that the explosion was a possible suicide. Walter had suffered recent business losses. The prosecution was faulted for poor police work. Jacobs had tried eighty major cases, eight of them murder cases, and he had never lost one. After two full days of deliberation, on October 5, 1947, the jury found them not guilty. Spectators cheered the verdict. Wilson called this decision "one of the most outrageous miscarriages of justice in the last 100 years." The verdict can be compared to that of the O.J. Simpson, Robert Blake and Casey Anthony trials.

Life after the trial was not good for the couple. After their profound professions of love for each other, the two did not marry. As Beulah

Louise left the courtroom, she was asked if she still intended to marry Gollum. She replied, "No." Asked the same question, Gollum replied, "We will see." Beulah Louise's inheritance was not as large as expected. She had to sell her home to cover legal fees. She married twice. Her first husband, Robert Cameron, was a Los Angeles police officer. They had one child. Wilson believed that Beulah Louise had a conscience and that her conscience killed her. She drifted into alcoholism and was found dead in Las Vegas in 1965. There were two empty bottles of vodka at her bedside and a loaded .22 rifle by her feet. The coroner attributed her death to acute alcoholism. Gollum went on to work for a carnival and served time for car theft. He was married twice and had two children. Later in life, Gollum went into agriculture and was growing marijuana for profit. He went to jail for selling marijuana at the age of eighty. He died in Wasilla, Alaska, in February 2009. He was eighty-three.

The refloated and repaired yacht *Mary E* was last in the news in 1960, when it was found to be operating as an offshore abortion clinic.

Young Pilot Crashes into the Fog-Shrouded Mountains, 1948

After World War II, the thousands of warplanes that had been produced became obsolete. The vast majority were scrapped for their metals, but some were put up for sale for ridiculously low prices. At the same time, there were plenty of young men who wanted a thrill, and it was cheap and easy to get a pilot's license. In the late 1940s, many new pilots squeezed into the cockpits of warplanes that were too powerful for novices to handle.

In 1948, one such young man, twenty years old, with his pilot's license just issued, bought a surplus wartime training plane and took it up. On a Tuesday evening when fog hung on the valley in a thick blanket, residents heard an airplane cross the valley, flying through the thick overcast. Several heard the crash when the pilot flew straight into the side of the San Gabriel Mountains. The Mounted Posse, the precursor of the Montrose Search and Rescue Team, was mobilized, and the crash site was soon found in the dark. The plane had crashed in Ward Canyon, above the Ananda Ashrama at the top of Pennsylvania Avenue and just to the east of Dunsmore Canyon. The pilot had died on impact, and his body was recovered and carried on a litter down the steep ravine by the rescue team.

Recently, a local "aircraft wreck hunter" has scoured the area described as the crash site, hoping to find some trace of the crashed airplane, but to no avail. It's thought that the wreck was probably covered by mudslides in the several fires and floods that have happened since the late '40s and that the wreck will never be found.

CARYL WHITTIER CHESSMAN, 1948

The Red Light Bandit

In May 2001, Ruben Patterson, a professional basketball player for the Seattle Supersonics, was convicted of attempted rape after he forced his children's nanny to perform oral sex on him. His punishment was a suspended sentence that consisted of fifteen days under house arrest. He was also suspended for five games. "I'm not no rapist!" beamed Patterson as he signed a contract with the Portland Trailblazers for $33.5 million. "I'm a great guy!"

This is how we treat people convicted of forced oral sex today. Listen to what happened to Caryl Whittier Chessman for the same crime.

The poet John Greenleaf Whittier, gave his name to Whittier, California, and Caryl Whittier Chessman. Chessman did not bring honor to the name. He was one of the most famous criminals of the '40s and '50s, although he is virtually unknown today. He wrote five books while on death row: *Cell 2455, Death Row 1954, Trial by Ordeal, The Face of Justice* and *The Kid was a Killer*. His books were translated into eighteen languages. While on death row, he learned four languages and became one of the most successful defense attorneys in California as he attempted to stay alive. His battle lasted a record twelve years and through nine appeals. In the end, he died because of a misdialed phone number.

Chessman was a career petty criminal. From the time of his first arrest for auto theft at sixteen until his death at thirty-eight, he was out of jail for only two years. Chessman's youth was tragic. He suffered three serious illnesses in his early years. His father was paralyzed in a traffic accident and unemployed. His father attempted suicide twice. Chessman was a graduate of Glendale High School, where he did poorly. He was undernourished, skinny and poorly dressed. He was a scapegoat and was bullied. He turned to crime, mainly robberies. He got into fights, which led to many arrests and beatings by the police. He was married twice,

briefly. Chessman became known as the red-light bandit. Chessman's MO consisted of using a red light as he approached lovers at such places as the overlooks near Flintridge Sacred Heart Academy. The lovers would believe he was the police. Chessman was captured after a five-mile, ninety-mile-per-hour chase down Vermont Avenue complete with gunfire. He was charged with eighteen felony counts, including robbery, kidnapping (with bodily harm) and rape. The rapes consisted of oral sex. Under California's Little Lindbergh law, kidnapping with bodily harm was a death penalty offense. Chessman dragged Alice Meza, seventeen, from her car and demanded oral sex. He took Regina Jackson and dragged her twenty-two feet from her car for the same purpose. Because of this, these cases were defined as kidnappings. The Little Lindbergh law was repealed in the 1950s but was not applied retroactively. In one of Chessman's books, he states that an attorney offered to take his case and guaranteed him an acquittal. Chessman asked how he could give a guarantee. The lawyer replied, "I do not take cases I can lose." Chessman said it was one of his greatest regrets that he could not afford the man's fee. He acted as his own attorney. This was a fatal error. Chessman was his own worst enemy. He appeared arrogant and cold hearted. He showed himself as a sociopath. His inexperience allowed the prosecution to impanel a jury of eleven women in a rape case. Despite the fact that the victims failed to pick him out of a lineup and their descriptions of the attacker did not resemble Chessman, the jury convicted him on seventeen of the eighteen counts against him. The conviction carried an automatic death penalty.

Lawyer George T. Davis later became Chessman's defense attorney. He feels that Chessman never got a fair trial because he had embarrassed the California justice system. Chessman supporters included the writers Aldous Huxley, Ray Bradbury, Norman Mailer, Robert Frost and William F. Buckley. Entertainers who came to his aid included Marlon Brando, Shirley MacLaine and Steve Allen. Some prominent religious figures were in his corner as well, including Billy Graham. Other supporters included Melvin Belli, Albert Schweitzer and former first lady Eleanor Roosevelt. Outside San Quentin on May 2, 1960, was the current Governor Jerry Brown, nineteen at the time, protesting the execution of Chessman. His father, then-governor Pat Brown, was permitting the execution to go forward.

On May 2, Chessman was seeking another stay of execution. The defense attorney's appeal was fifteen pages long. The judge did not begin to read the appeal until 9:00 a.m. The execution was scheduled for 10:00

a.m. The judge read each page, and one minute before the execution, he granted the stay. The judge was not in a hurry, even with a man's life on the line. He instructed his secretary to call the death chamber and stop the execution. He gave her the number of the gas chamber. She left the room and returned shortly after to ask for the number again. When she finally got through to the gas chamber, the execution was already in progress. So Chessman was executed because of a wrong number, compounded by a seemingly wordy appeal. Chessman is one of the few people to ever be executed for a crime where no one was killed. To add insult to injury, he was denied burial at Forest Lawn in Glendale, California, on moral grounds.

Family Shooting and Suicide on Stevens, 1949

In August 1949, Murray James, unemployed for three months, suddenly snapped. He went on a shooting spree in his family's small house in the 3500 block of Stevens. He shot his wife in the chest and his stepson in the stomach, seriously wounding both of them. At that point, he paused in his rampage to take his three-year-old son to a neighbor's house. He then returned to his own home, where he turned the gun on himself and committed suicide.

Boy Drowns in Open Reservoir, 1949

In the postwar building boom, many families with children moved to the Crescenta Valley. Bodies of water naturally attract kids, so the small ponds in unfenced debris basins and open reservoirs along the base of the San Gabriels and the Verdugos became playgrounds—and sometimes deathtraps.

In 1946, two boys drowned in the Pickens Canyon debris basin, and in 1949, a similar tragedy struck on the other side of the valley near Whiting Woods. Several boys were playing cowboys and Indians in the neighborhood near the intersection of Cloud and Sycamore Avenues. They were building a fort out of scraps of wood, and one nine-year-old, dressed as an Indian, went off to find more wood. When he didn't return,

the boys reported him missing to their parents. The sheriffs eventually located his body, still wearing a warbonnet and his face daubed with war paint, in a small, uncovered reservoir near Verdugo Creek. The boy had apparently slipped and fell into the underground, spring-fed reservoir. The property had been owned by Perry Whiting, and the reservoir had been built in 1913, when he first bought the canyon now known as Whiting Woods.

Chapter 5
1950s

Policeman in the Wrong, 1956

A murder charge was brought against William E. Bowman, a thirty-one-year-old machinist. He was accused of shooting to death Officer Samuel T. Justice, thirty-two, a Montrose resident, with a shotgun. Bowman claimed self-defense. Bowman stated that Officer Justice and he had an argument in a bar. Justice followed him to his home in the 2500 block of Manhattan Avenue in Montrose. He stated that when Justice tried to force his way into Bowman's home, Bowman fired a warning shot over Justice's head. Justice replied with three shots through Bowman's front door. Bowman then fired one blast from his 16-gauge shotgun. The blast struck Justice in the throat. Defense attorney James O. Warner brought Bowman's apartment door into the courtroom to illustrate how Justice had fired into the apartment. The jury in superior court with Judge Charles W. Fricke presiding took three hours before accepting Bowman's statement that he had fired in self-defense and fear of his own life. They pronounced him not guilty on December 19, 1956.

Murder at a Crowded La Cañada Restaurant, 1957

Perhaps the corner of Angeles Crest and Foothill Boulevards occupies the site of an ancient Indian burial ground. The location has certainly

brought bad luck to more than one person. Recently, a runaway truck slammed into cars and buildings, killing two at that intersection. In 1956, there was a murder committed there. On February 14, 1957, Mrs. Dorothy Scaggs, a waitress at the restaurant where the Hill Street Café is today, was murdered by her husband. After Kenneth Scaggs's arrest, he admitted to the murder. He stated, "When I got up this morning, I had it in my mind that I was going to go down and kill her." Kenneth said that he and his wife had a series of vicious quarrels in the weeks leading up to her murder. He said he had moved out of his home at 10021 Fairgrove Avenue in Tujunga and had taken his three older children, Ginger (ten), Patricia (seven) and Gail (five), with him. Ken Jr. (four) and Dorothy (three) stayed with their mother. Kenneth arrived at the restaurant before noon. The restaurant was filled with the typical lunch crowd. Mrs. Scaggs spoke to her husband and told fellow waitress Mrs. Mary Campbell, "He wants to try again. He says the kids have been crying for me." Upset, Mrs. Scaggs returned to her husband. There was another argument, and he proceeded to fire five bullets into his wife. Tom Buchwalter (forty) of Pasadena, California, who was a close friend of Mrs. Scaggs, took the weapon from Kenneth Scaggs. Kenneth quietly waited for the police. Mrs. Scaggs was taken to Glendale Sanitarium, which is now Glendale Adventist Hospital. She passed away two days later. Kenneth, after dinner in jail, slashed his wrist with a broken dinner plate. He was also taken to Glendale Sanitarium. After he was stabilized, he was transferred to General Hospital Prison Ward. The crime was stupid. A mother was murdered, a father was sent to prison and five children were left parentless.

THE CRESCENTA VALLEY SHERIFF WHO GAVE HIS LIFE, 1957

Deputy David Horr had been at the Montrose Sheriff Station for only a few months by the evening of December 7, 1957. He and partner Deputy Charles Manuel were dispatched to investigate a loud disturbance and possible gunshot at a house on La Crescenta Avenue just below Piedmont. For Deputy Horr, this was just around the corner from his own house on Raymond Avenue, where he lived with his wife and three boys, making this call "close to home." As the first officers on the scene, Horr and Manuel approached the small frame house from the front. Observing that all the lights were on, they knocked on the front door but got no answer. They

walked around the house to try the back door. Horr stood in front of the door and knocked while Manuel stood off to the side.

Deputy Horr's knocks were answered sharply by a shotgun blast through the door. Over one hundred 16-gauge shotgun pellets hit Horr square in the abdomen, mixed with an equal amount of glass and screen-door particles. Horr fell backward and, lying stunned and bleeding on the ground, shouted a warning to his partner, "Get away! I'll make it! Block off the street or somebody will get hurt!"

Quickly, fifty officers surrounded the house and ordered the occupants out with a loudspeaker. After a brief standoff, a lone man walked out of the house and surrendered. The Browning shotgun was found in the attic of the house where the gunman had tried to hide it after firing the shot, and nine spent shells were found inside the house.

Deputy Horr was taken by ambulance to Glendale Memorial and operated on by Dr. John Paxton and Dr. Frank Paxton, brothers. Deputy Horr was a mess internally. A section of his large intestine had been blown away, and the resulting fecal matter, mixed with the shotgun pellets, glass and rusty screen-door particles, created a toxic mixture that was impossible to clean out. He was in for a long and painful struggle with the resulting massive infections.

In a cruel coincidence, Deputy Horr's mother, Adah Horr, had suffered a stroke just days before and was a patient in the same hospital. She died several days later, never knowing her son was fighting for his life just a few rooms away.

Deputy Horr fought death for weeks, battling constant infections and abscesses. All that was possible with '50s-era medical technology was done for him at Glendale Memorial, but it wasn't enough. After several more surgeries, pints and pints of donated blood and the primitive antibiotics available then, Deputy David Horr finally slipped away on February 9, 1958.

Former Crescenta Valley resident Mike Love told a very sad side story to this unfortunate chapter in our local history. According to Mike, Deputy Horr's wife was the den mother to Mike's Cub Scout den pack. In the pack as well was Deputy Horr's son, along with the son of the murderer. Mike said that in the pack meetings after the shooting, Mrs. Horr treated the murderer's son no differently than the other boys, which must have taken an incredible amount of strength.

Mrs. Horr soon moved away and eventually remarried, and her new husband adopted the boys. Deputy David Horr's son Donald Sutton, now in his early sixties, has perhaps sought some closure to his father's death and

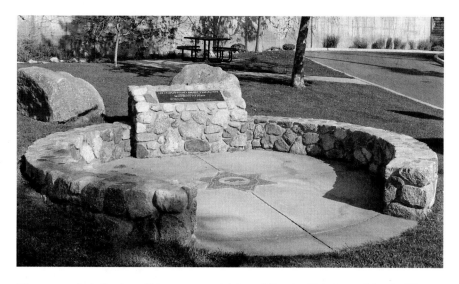

The community built a beautiful stone memorial site to fallen sheriffs in front of the sheriff station on Briggs Avenue. It memorializes the sacrifice for our community's safety made by Deputy David Horr in 1957. The plaque also memorializes the only fallen Montrose Search and Rescue Team member, all of whom are sheriff reserve deputies. *Photo by Mike Lawler.*

has been the guiding force behind a tribute of some kind to his father. He and the community built a memorial at the Crescenta Valley Sheriff Station on Briggs. The native stone design holds a bronze plaque with the names of two local sheriffs who died in the line of duty. It's located prominently near the front entrance and is worth a visit. While there, ponder the price some have paid so that we can live in a peaceful community.

CAR OFF A CLIFF IN ANGELES FOREST, 1957

There have been literally hundreds of fatal car crashes on the treacherous mountain roads of the Angeles Forest. Angeles Crest Highway, Angeles Forest Highway and Big Tujunga Canyon Road have all claimed the lives of motorists in the decades since they were built. In the early years, cars did not have the superior handling, braking and crash-worthy characteristics of modern cars, and those facts, combined with a tolerance and even acceptance of drinking and driving in that era, were a recipe for disaster. This accident was a typical sample of the type of mountain road accident that was all too common.

In February 1957, the tender of Tujunga Dam was driving home from his shift in his 1956 station wagon. He lost control on a hairpin turn and hit the inside bank of dirt, caroming off across the road and hurtling off the cliff. The car fell seventy-five feet, where it hit a ledge and then tumbled another three hundred feet to the bottom of the ravine. The driver was crushed inside.

Sheriff's Emergency Reserve members responded and were able to get a cable down to the wrecked vehicle. It was winched back up to the road, and the driver's mangled body was removed. A photo of the wreck in the *Crescenta Valley Ledger* is barely recognizable as a car and more resembles a wadded-up piece of tin foil

La Cañada Doctor Beaten by Drunks, 1957

One evening, in February 1957, a doctor living on Mellow Lane in La Cañada had fallen asleep on his couch. At 3:00 a.m., he woke up and went outside to his car to retrieve a bag before going to bed. Just as he reached his car, another car with two men in it pulled into his driveway. The driver got out and asked the doctor for a "Joey Hatfield," who had formerly lived there. The doctor told him he wasn't there. The man was obviously drunk, and when he got into his car and backed out of the driveway, he hit the doctor's mailbox. The doctor yelled at them to leave, at which point the two men jumped out of the car and attacked the doctor, beating him with their fists. One man grabbed the doctor's tie and began to strangle him, while the other kicked him viciously. At some point, one of the two said, "Stop before you kill him," and the men got back into their car and drove off. A neighbor heard the commotion and found the doctor hanging on to his broken mailbox, covered in blood. The doctor had suffered a broken nose and kneecap and a fractured vertebra. He was able to give a good description of the car and the assailants, and they were picked up in Pasadena and charged with assault.

Chapter 6
1960s

THE ONION FIELD MURDER, 1963

Most of the information in this section is taken from Joseph Wambaugh's masterful work *The Onion Field*. On the night of March 9, 1963, Los Angeles Police Department plainclothes officers Ian Campbell and Karl Hettinger pulled over a suspicious-looking vehicle. The car contained Gregory Ulas Powell and Jimmy Lee Smith. The officers were two of Los Angeles's finest, while Powell and Smith were two pathetic losers, leading useless and wasted lives.

Powell was the leader of the two criminals and had delusions of adequacy. He was caught up in the romance of being a dashing criminal. He was considered smart but emotionally unstable. Powell's life of crime had begun at the age of sixteen, when he stole money and a car from his sister. He was sent to a juvenile detention facility, from which he escaped, and was later sentenced to a federal reformatory. Powell said that he realized that at eighteen, he was an institutional man. He felt that he could only function in the confines of a prison. His problem, as he saw it, was that the authorities kept releasing him from prison against his will. At eighteen, he stole a car again and was released from prison at twenty. He was then in and out of prison constantly. He had a craniectomy at Vacaville to remove a tumor. He was paroled May 1962. He was twenty-nine and had spent ten of his previous thirteen years in prison. Powell considered himself a master criminal and claimed to have planned his robberies very meticulously. Even if he had planned his crimes carefully, it would have made no difference because he

would disregard all his own plans and rob on the spur of the moment. He was a braggart and claimed that he could do anything. In truth, he could do little right. Jimmy Smith, his cohort in crime, was a follower and knew that Powell was bad news. He planned repeatedly to abandon Powell but never found the courage to do so.

Jimmy Lee Smith had been abused by his stepfather and began stealing at an early age. He was a con man and had two illegitimate children whom he never supported. Five months was the longest period of freedom Smith had in his adult life as he pursued his career as an addict, a shoplifter and a petty thief. The extent of Smith's dream was to have a transportation car, a job as a painter, some clothes, good food, a few records, a TV and a woman. The woman was just another possession to Smith, similar to a television or a toaster.

Officer Ian Campbell was thirty and married with children. He had joined the police department after dropping out of a premed program.

Karl Hettinger of La Crescenta was twenty-eight years old and married. He had entered Pierce Junior College at age sixteen and had joined the police force after dropping out of Fresno State in his final semester. He was a city boy who aspired to be a farmer.

Powell and Smith were pulled over for making an illegal U-turn and having a broken license plate light. The officers were suspicious of the two men with snap-brim hats and leather jackets. Wambaugh wrote that they looked like two actors out of central casting. What the officers did not know was that the pair had robbed four liquor stores and was on their way to rob an additional store or two. Powell pulled a gun and disarmed Officer Campbell. With his gun on Campbell, he told Hettinger to give up his weapon. Officer Campbell also told Karl to give up his gun. Karl did so reluctantly.

Powell and Smith told Campbell and Hettinger that they were going to drive them to the middle of nowhere and release them. When they arrived at the desolate onion field approximately one hundred miles from Los Angeles, Powell said to Campbell, "We told you we were going to let you go, but have you ever heard of the Little Lindbergh law?" He was referring to the law making it an automatic death penalty for the crime of kidnapping. Officer Campbell said yes, and Powell shot him in the mouth. As Campbell lay on the ground, four more bullets were fired into his body. It was never determined which of the two criminals fired those four bullets. Pierce Brooks, a detective working the case, saw that the murderers could do nothing right. The Little Lindbergh law applied only to kidnapping for ransom or great risk of bodily harm. Campbell died of Powell's stupidity. When Campbell was shot, Karl

ran in terror for his life. He ran four miles to a farmhouse. Once in a safe location, his police training took over. He was able to give clear and accurate descriptions of the crime and its perpetrators. Powell was apprehended several hours later, and Smith was taken into custody the following day.

Karl was back on duty the next day. He would become a victim of the police culture. According to Wambaugh, police are trained to believe that they can always do something to gain control of a situation, no matter what the circumstances are. Therefore, by police thinking, Karl and Ian had failed. Karl accepted this thinking, and his emotionally repressed childhood memories compounded his situation. The LAPD had little understanding of the impact of emotional stress in the 1960s. Karl was suffering from what we know today as post-traumatic stress disorder (PTSD). The police had no support for Karl and condemned his actions. In addition, Karl did not seek help and refused to talk about his problems, even with his wife. The case of Ian and Karl became a study in what police should not do. Patrol bureau referendum number eleven, a direct reference to Karl's actions, became police policy and then was quickly taught at the academy. The memorandum said, "Never give up your weapon."

Still living in La Crescenta, Karl suffered crippling bouts of depression. He would relive the incident in his dreams almost every night. He lost twenty pounds and an inch in height. He suffered recurring diarrhea, severe headaches and chest pains. Karl's problems were exacerbated because the case dragged on for six and a half years. He had to relive the events in court at least seven or eight times. Every minute action was picked over and criticized. The case record came to forty-five thousand pages and 159 volumes. It was the longest case in California history. It required twelve judges and numerous attorneys. Karl was forced to retire from the LAPD in 1966 after being accused of shoplifting. Karl's life got better after 1971. His memory improved, he took classes at UCLA and his bad dreams came less frequently. He was offered his dream job in 1972, farming in Kern County. He was appointed to serve as Kern County supervisor for Bakersfield. He served from 1987 to 1992.

Ian Campbell died in the onion field in 1963. In many ways Karl Hettinger also died in that field. Because Ian was a bagpiper, the bagpipes are played in his honor at all LAPD funerals. Karl Hettinger died in May 1994 of natural causes. He was fifty-nine years old. LAPD police chief Daryl Gates said of Campbell, "He was a great police officer and a great man. He always felt guilty because he ran. If he had stayed, he would have been dead." Just as Ian was murdered by Powell and Smith, so was Karl. It just took him thirty-

one years to die of his psychological wounds. Jimmy Lee Smith was released from prison in 1982. He was in and out of prison until his death in prison in April 2007. He survived Ian by thirty-seven years and Karl by thirteen. Powell was denied parole on eleven separate occasions and died in prison in August 2012. He was seventy-nine years old.

Gun Battle in Montrose, 1965

Burt Seacrest, twenty-nine, of 2200 block of Del Mar Road, was taken into custody after an hour-long gun battle with fifteen police officers, deputy sheriffs and highway patrolmen. According to police, Seacrest returned to his home at 4:30 a.m. after a night of drinking. He threatened to kill his wife, Betty, thirty-four, with a knife. He called the Montrose substation and told them he was going to kill her. Police officers William McElhiney and Amos Lewis responded to the incident. When they arrived at the scene, they were met by a hail of gunfire from Seacrest's home. Seacrest ran from the home firing at the officers. He hid in the bushes. Officers Hal Pitts and William Stark of the Glendale Police Department were able to talk him into surrendering. As he was being escorted to the police car, he broke away, pulled a pistol from his sock and fired at two photographers. Fortunately, the gun was defective and misfired. The police recovered a .22-caliber rifle and two pistols at the scene. Seacrest said to the officers, "I only have one regret. I wish I would have shot one of you guys." Seacrest was found guilty of assault with a deadly weapon and attempted murder on March 21, 1965. The sentence was pronounced by Judge Richard Hayden on March 24 pending the outcome of a sanity hearing.

Bride Murdered at Devil's Gate, 1968

Anna Elizabeth Payne had been married for five months. She had met her husband, Larry Payne, twenty-five, via pen-pal correspondence. Larry Payne was a technician at JPL's Goldstone tracking station. The Paynes were living in Barstow. Larry Payne was completing a two-week seminar at JPL. The seminar was to be completed one day after the murder. The Paynes were living in a trailer at Devil's Gate Dam. The location was ideal as Larry

was an avid hiker and Anna enjoyed long walks alone. Larry Payne said he left the trailer at 7:00 a.m. on Thursday to attend the seminar. He returned to the trailer at noon to have lunch with his wife. She was not there. He was not concerned, as she often took long walks into La Cañada to pick up their mail. On Thursday, a police officer noticed a fire in Flint Canyon. When the fire department arrived at the scene, they discovered Anna's body. Detective Lieutenant Gerald Wright said the fire was either started to remove evidence or to attract attention to the body. When Anna was found, she was only wearing a bathrobe and a brassiere. The brassiere had been used to strangle her. A bloodstained rock was found near the body. The autopsy attributed her death to extensive head injuries, a skull fracture and strangulation.

MONTROSE SEARCH AND RESCUE, 1969

"Man in the Water!"

In the winter of 1969, Los Angeles was in the grip of the fabled "100-year flood." The mountain communities were the hardest hit, as over fifty inches of rain poured down on the San Gabriels, turning every creek into whitewater rapids. The raging river in Big Tujunga Canyon had spread across the entire canyon floor, and the reservoir behind Big Tujunga Dam was full of accumulated debris from farther upstream. Water and logs, plus big sections of dredging equipment from work being done at the reservoir itself, were coming over the top of the dam and, carried by the torrent, blasting down the canyon. As bridges and roads washed away, the Montrose Search and Rescue Team patrolled the canyon, helping with evacuations and checking the safety of those choosing to stay behind.

On January 26, the team got the call to the Big Tujunga Ranger Station near where thirty-two residents of La Paloma Flats were trapped on the wrong side of a washed-out bridge and a sick child desperately needed medical aid. Reaching the stub of the destroyed bridge, the ten members of the search-and-rescue unit split into two teams. One team would try to get a line across the gap between the two sides of the washed-out bridge, while the other would go upstream and try to "island hop" across the many debris piles hung up in the rushing water.

The bridge team had early success by using a bow and arrow to shoot a fishing line across the gap. Successively larger lines were pulled across,

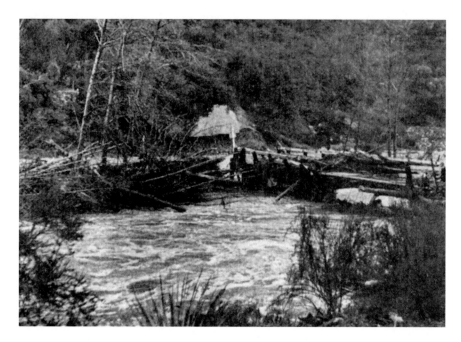

The Big Tujunga Creek is normally a peaceful, small stream, but in the winter of 1969, it became an angry, raging torrent. Bridges across the stream like this one were washed out. The Montrose Search and Rescue Team was called in to rescue those trapped on the other side. *Courtesy of the Glendale Library.*

until finally a taut cable was fixed and a team member was able to hand-over-hand his way across the torrent. This team would definitely be able to retrieve the sick child.

Not knowing of the other team's success, the upstream team, which included Charles Rea, used its ingenuity to get across the raging torrent. Scrambling over loose and slippery debris piles, the team members bridged the biggest stream by cutting down a tree so that it fell across the gap, about four feet above the now rising water. Charles Rea got across the log bridge and strung a hand line across to create a walkway. Rea clipped his safety harness onto the hand line and started back across the slippery fallen tree. Halfway across he lost his footing and, still tethered to the hand line, plunged into the water on the upstream side of the log, disappearing from sight. Another team member scrambled out on the log where Rea's safety tether was attached, holding him fast to the taut hand line, and reached down into the raging water. At one point, he felt Rea's hand, grabbed on and pulled with all his strength. The incredible power of the rushing water was holding Rea down, and no amount of pulling on Rea's arm or his safety

harness could budge him. As team members frantically tried to pull Rea's body up, the rising water began to wash away the debris islands that were the team's bridge to safety, and even the log bridge began to shift. The would-be rescuers had to retreat.

Agonized Montrose Search and Rescue members, along with sheriffs and crews from the Forest Service, spent hours trying to retrieve the body. Finally, the dam-keeper upstream was able to temporarily cut off some of the flow from the dam, and the next day, the water lowered enough to retrieve Rea's body.

Rea was a successful young man and left behind a wife and four young daughters. His loss, the first and only for the Montrose Search and Rescue Team, sobered our community and reminded us what sacrifices the team makes for us.

The Montrose Search and Rescue Team is an all-volunteer group made up of our neighbors, and they put themselves in harm's way to save lives. Fortunately, only once has that sacrifice been ultimate. Montrose Search and Rescue volunteers are members of the Sheriff's Reserve, and so the Sheriff's Memorial in front of the Crescenta Valley Sheriff Station honors Charles Rea with a plaque.

Chapter 7
1970s

Angeles Forest Beating and Robbery, 1971

In February 1971, two workers asked their Glendale boss to come and inspect a sandblasting job they were doing on a water tank in an old detention camp on Angeles Crest Highway. When the Glendale man arrived in his car, he was met by one of the men wearing a ski mask and holding a revolver. The man in the mask demanded the Glendale man's money and then began to beat him with the pistol, fracturing his skull. The other worker, who had previously worked for the Glendale man, emerged from the bushes and cut the man's pants off to get his wallet, which contained $4,000 in cash. The Glendale man was able to escape back into his car and drive off, but the two men chased him in their vehicle and repeatedly tried to run him off the road. The chase ended when they met up with a Forest Service worker, who radioed police. The two assailants fled, but their car was soon located by helicopter with one of the assailants still inside. The other attacker was picked up two days later trying to hitchhike out of the forest. The $4,000 was never located and was thought to have been hidden somewhere along the highway. Both attackers were convicted and sentenced to five years to life in prison.

Youth Arrested for Grandmother's Murder, 1971

In 1971, a young Montrose man was staying with his grandmother near Kenneth Road in Glendale while on vacation from college. His father at the family's home in the 2300 block of Barton Lane received a call from his son, who said that he thought his grandmother was dead. The father called an ambulance to go to her house in Glendale, and when the ambulance crew arrived at the home, they found the grandmother strangled to death and the grandson gone. Police soon received a call from a Pasadena psychiatrist saying that the boy was at her home in a deep state of shock. The boy was arrested for murder.

Death at Tony's Tackle Store on Foothill, 1972

Tony's Tackle Store had stood quiet and closed for years, gathering dust. Looking through the windows, you could see sporting equipment, BB guns and very old fishing bait. Not knowing the story, people would often speculate about what went on there. Local teens said that it was a drug

This is the former site of Tony's Tackle in the 2700 block of Foothill Boulevard. In 1972, the brutal robbery and murder of owner Tony Campanelli shocked the Foothills communities. Today, California Waterscapes, a pond supply store, has made the interior of the site of the tragedy a very peaceful and beautiful place. *Photo by Mike Lawler.*

distribution center. The real story is far more bizarre. Joe Campanelli was the original owner. When he retired, his son inherited the business. On July 24, 1972, Tony Campanelle was murdered in his shop between 8:30 a.m. and 9:10 p.m. Sheriff Peter J. Pitchess sought the public's assistance, as the only clue the police had was the presence of a fire engine red 1954–55 MG sports car. The MG was seen parked in front of the store prior to the discovery of Tony's body. One Caucasian man was seen sitting in the vehicle. Tony's badly beaten body was found behind the counter at 9:30 p.m. by a female customer. According to the Sheriff's Department, Tony had been shot execution style. The police suspected robbery, as over $700 cash, a .357 Magnum handgun and a rifle (with its scope) were missing. On July 31, sheriffs' deputies set up roadblocks and stopped and questioned six hundred people who might have been passing by at the time of the murder. They hoped to uncover additional clues. The murder has never been solved and rumors continue to grow. According to some, it was an execution-style mob hit. If so, the owner of the bright red MG is probably not involved, as a mob killer is not likely to use a vehicle that stands out. Tony's Tackle Shop is now the Pacific Design Shop.

Foothill Freeway Bridge Collapse, 1972

Most of the information here was taken from the *Ledger* and written by assistant editor Mike Pottage and staff writer Jean Evans. There is little that could be added to their coverage of the tragic bridge construction accident in 1972. Hundreds of tons of wet concrete, steel beams, supports and a crew of workmen plunged into the Arroyo Seco on the eastern edge of La Cañada. The accident took place while concrete was being poured to create a freeway bridge over the deep canyon. Two of the six victims were entombed in the quick-dry cement. One worker actually described having run off the bridge as it was collapsing beneath him. Rescue work continued into the night.

Almost before the sound of death and disaster had finished echoing across the Arroyo, construction crews, firemen, city employees, state officials and everyone connected with disaster work and the Foothill Construction Project began the grim task of sorting through the rubble and looking for survivors and bodies. The light cast eerie shadows on the floor of the Arroyo Seco, where hundreds of men worked feverishly to extricate their fallen co-workers. Pasadena fire chief D.B. Holmes said at 3:15 p.m., an hour and

forty-five minutes after the collapse, "I always have hope. We know there are men in there. I always have hope." Despite the chief's fervent wish, all the men who were to come out alive had already been removed and were in Pasadena hospitals.

The contractor on the 1.5-mile segment of the I-210 freeway was Polich-Benedict. (This was the second disaster to strike a Polich-Benedict bridge project. Another structure at the interchange of the I-10 and I-605 collapsed just before the I-210 accident, killing a motorist.) Damage, liability and reconstruction cost ran into the millions of dollars. More than three hundred rescue units arrived within the hour. Pasadena fire, police and city crews were in charge, along with contractor and constructions crews. Aid came from the Los Angeles Fire Department and the Los Angeles County Sheriffs' Deputies, as well as the Sierra Madre, the Altadena and the Montrose Search and Rescue teams. The U.S. Forest Service, county camp crews, volunteers from the Union Hall, state disaster office and others came to help as well. Long Beach sent in a twelve-man disaster crew. Thirty to forty high school students helped by lining the path down to the canyon with their flashlights. Emergency calls went out to all Pasadena- and Glendale-area hospitals. Each was asked to accept as many emergency cases as possible. It was initially feared that there might have been as many as forty men dead or injured. The rescue work began as crews carried off timbers, and welding torches were used to cut the steel reinforcing. A large crane was brought in to lift off

In 1972, a sixty-foot section of the partially completed I-210 freeway bridge over the Arroyo Seco near Devil's Gate Dam suddenly collapsed while cement was being poured. Six workers were killed and another twenty-one injured. Crowds gathered on Oak Grove Drive to watch the rescue efforts. *Courtesy of the* Glendale News *Press.*

tons of wreckage. The rescue crews risked their lives by carrying debris out by hand. Spotters kept their eyes on the accident site, constantly looking for signs of life. They also kept an eye on the remains of the bridge to be able to warn those below, if something was about to fall. Division of Highway District Seven officials said that the bridge failure was the worst disaster in its history. It was not known at the time the article was written how much of the remaining portion of the six-hundred-foot-long bridge would have to be torn down and reconstructed. Ted Polisch, secretary treasurer of the Polisch-Benedict Firm, asserted, "To this hour we have no idea as to the cause of the tragic collapse."

TEEN GOES BERSERK ON DRUGS, 1973

In September 1973, two boys, both seventeen, from the South Bay area of Los Angeles were camping in the Angeles Forest. They had both taken LSD. At 1:00 a.m., one boy stabbed the other in the chest with a knife. The attacker ran off, and the wounded victim walked a mile to the Clear Creek Forest Service Station. Meanwhile, the assailant, still high, fled to another campground, where the campers there kept the crazed youth away by threatening him with an axe. He soon wandered off and stabbed himself in the stomach with the knife. Montrose Search and Rescue members found both boys and transported them to Verdugo Hills Hospital. Both were arrested on drug possession charges, with the attacker being charged with attempted murder.

HORSEBACK RIDER STABBED TO DEATH, 1973

Two youths were riding a single horse in the Arroyo Seco around Christmas 1973. A boy, thirteen, was at the reins, and his friend, a fourteen-year-old girl, was on the saddle behind him. As they approached the parking lot of JPL, they were accosted by a seventeen-year-old boy, who demanded that they get down off the horse. The younger boy refused, so the seventeen-year-old stabbed him with a knife and fled. The boy bled to death soon after. The girl was able to identify the attacker, but he turned himself in before police arrested him.

HILLSIDE STRANGLERS, 1977

On Halloween morning in 1977, La Crescenta awakened to horror. The body of Judy Miller, a fifteen-year-old, ninety-pound prostitute was found on Alta Terrace. The foothills did not realize that terror would strike the area for the next several years. Much has been written about these murders, including *Two of a Kind: The Hillside Stranglers* by Darcy O'Brien. Judy Miller was the second victim of the Hillside Stranglers. It would be almost five years and ten murders before Angelo Buono and Kenneth Bianci were sentenced for their crimes. Meanwhile, Laurence Bittaker and Roy Norris, two more sociopaths, were dumping their gruesome cargoes on our doorsteps.

Angelo Buono was five feet, ten inches tall and forty-four years of age. He was a vile, disgusting brute of a man. He was not considered good looking but seemed to attract a constant stream of women. He called himself the "Italian Stallion." A few of the women who crossed his path were raped, tortured and murdered. Angelo was a lifetime petty criminal. He claimed Caryl Chessman as his hero. He had eight children with three separate women. He never took responsibility of any kind for his children. He physically abused all of his children and his wives. He molested his fourteen-year-old stepdaughter. He hated women and wanted to injure and manipulate them. He had boasted that at fourteen years of age, he had raped and sodomized a neighbor girl. Angelo lived, worked and murdered at his upholstery shop in the 700 block of East Colorado Boulevard, Glendale. He walked our streets and ate breakfast every morning at either Henry's or the Copper Penny.

Kenneth Bianchi was his twenty-six-year-old cousin and partner in crime. Bianchi had delusions of grandeur. He thought he should have been a statesman, an artist, a doctor or a policeman. He was a compulsive liar who was rejected as being psychologically unfit by the Los Angeles Police Department, the Glendale Police Department and the LAPD Reserve Officers Program. He was born in 1951 to an alcoholic prostitute mother who gave him up for adoption. During the time of the murders, he was working at Verdugo Hills Hospital and was often asked to walk female employees to their cars at night to protect them from the Hillside Strangler.

Yolanda Washington was their first victim. Her body was found dumped on Forest Lawn Drive. Lissa Kastin was dumped November 6, 1977, on Chevy Chase Drive near the country club. Jane King was dumped November 9, 1977, at Griffith Park. Perhaps the saddest victims were Dolores Cepeda (twelve years old and ninety-six pounds) and Sonja Johnson (fourteen years old, four feet, eleven inches tall and eighty pounds). The girls were students

This car was owned by Cindy Hudspeth, a student and employee of Glendale Community College. In 1978, her murdered body was stuffed in the trunk by Bianchi and Buono, the Hillside Stranglers, and pushed off the side of Angeles Crest Highway. The murdering duo operated out of Glendale and dumped many of their victim's bodies in surrounding communities, including La Crescenta. *Courtesy of murderpedia.org*

at St. Ignatius parochial school. Their bodies were found at Elysian Park. "Dump" seems like a harsh word, but it helps illustrate the killers' mindsets. Bianchi and Buono showed no emotion, empathy or humanity when they tossed the young girls' bodies away, as if they were no more than garbage. The two continued their murderous rampage with their next victim, Kristina Weckler. She was a twenty-year-old student at the Art Center of Design in Pasadena. She was Bianchi's neighbor on Garfield Boulevard in Glendale. On November 29, 1977, the body of Lauren Ray was found on Mount Washington. Then Cindy Hudspeth, a Glendale College employee, was found stuffed in the trunk of her vehicle, which had been pushed off Angeles Crest Highway. The last victim was Kim Martin. Her body was dumped on Alvarado Boulevard in December of that same year.

The killing stopped when Bianchi and Buono had a falling out, and Bianchi moved to Billingham Washington. These murders might have remained unsolved, but Bianchi couldn't leave well enough alone. He seemed to have wanted to prove to Buono that he was capable of murdering on his own. On January 12, 1979, Karen Mandic and Diane Wilder accepted a housesitting job from a security guard and friend. That friend was Ken Bianchi. The girls' bodies were found in their car. Bianchi was arrested and, during the

investigation, was linked to the Southern California murders. It took three and a half months to pick the jury for the trial. The trial included one thousand exhibits, 250 witness and eleven days for the closing arguments. Bianchi was on the stand for five months. It was the longest trial in U.S. history up to that time and cost $2 million. The jury received the case after two years, and after ten days of deliberations, the pair was found guilty of eight murders. Bianchi received two life terms in Washington and thirty-five years in California. Buono died at age sixty-seven in Folsom prison, but not before marrying for the fourth time on September 21, 2002.

In 2007, Buono's grandson Chris Buono shot his grandmother, Mary Castillo, and then killed himself. Castillo had been married to Buono and had five children with him.

LAPD Officer Shoots His Wife, 1977

In August 1977, a ten-year veteran LAPD sergeant and resident of La Crescenta sought out his estranged wife at a maternity shop in Glendale, where she worked. They had been arguing for weeks about the custody of their son and property settlements in their upcoming divorce. A little after noon, the officer entered the store and began to argue loudly with his wife about custody issues. He pulled out his revolver, shot her five times in the chest and then fled. She died soon after. The officer fled to Saint James Catholic Church near his home in La Crescenta, where he was arrested. He was convicted of first-degree murder and sentenced to life in prison.

Doctor Shot at the Hospital, 1978

Dr. Mervyn Isaacs was a well-known anesthesiologist and longtime resident of La Cañada–Flintridge. On March 26, 1978, at about 8:30 p.m., Dr. Isaacs arrived at the Huntington Memorial Hospital with his wife, Diane. He parked their car in the hospital's research parking lot, which was located across the street from the emergency room and the physician's entrance to the hospital. The lot was open to anyone who wanted to park there. While his wife was visiting a friend at the hospital, Dr. Isaacs saw some of his patients. At about 10:00 p.m., Dr. Isaacs, his wife and a family friend left the building

and went to the Isaacs' car. While Dr. Isaacs was moving some belongings from the backseat to the trunk, Mrs. Isaacs and her friend got into the car. As he was closing the trunk, Dr. Isaacs was grabbed from behind by a man who held a gun to the doctor's chest. Dr. Isaacs put up his hands and began to turn around very slowly. At that point, the assailant shot the doctor in the chest. The gunman then fled the scene and was never apprehended. As a result of the shooting, Dr. Isaacs sustained severe injuries, including the loss of a kidney. He continued to suffer much illness as a result of the attack and underwent three liver transplants. He died in 1993. He is survived by his wife, Dianne R. Isaacs of La Cañada–Flintridge. Most of this article was taken from the court record.

BITTAKER AND NORRIS, 1979

True Monsters

In 1979, the case of the Hillside Strangler was ongoing, and a new series of teen abductions and murders was about to take place. Despite all the publicity and concerns of parents, teenage girls were still seen hitchhiking on Foothill Boulevard in La Crescenta. The new monsters to visit our community were Lawrence Bittaker and Roy Norris, two sociopaths who were in many ways more repulsive than both Buono and Bianchi. Bittaker and Norris were habitual criminals who met inside a California prison. They bonded immediately like kindred murderous spirits.

Lawrence Bittaker was born on September 27, 1940. He was given up for adoption. Despite a reported IQ of 138, he dropped out of school at nineteen, and he didn't have enough intelligence to stay out of prison. His first conviction was for a hit and run in 1957, when he was nineteen. He was arrested again in 1957 for auto-theft. He received an eighteen-month sentence. In 1961, he was sentenced to one to fifteen years and diagnosed as a paranoid and borderline psychotic. Released in 1963, he was rearrested in 1964 for parole violations. In 1967, he was convicted of theft and given a five-year sentence. In 1970, he was arrested and convicted of burglary and attempted murder. He was diagnosed as a sociopath but released again in 1978. This was a man for whom the three strikes law was designed. Bittaker was a failure of the prison system. He was repeatedly diagnosed with mental problems, and the judgment was that he would never stop his criminal acts.

Roy Norris's problems began in the navy. A conviction for four sexual assaults sent him to Atascadero State Hospital. He was diagnosed as a mentally disordered sex offender. In 1975, he was sent to the California Men's Colony. This is where he met Laurence Bittaker. In prison, the two made plans to kidnap and murder girls of each year's age between thirteen and nineteen. They were determined to see how long they could keep them alive and screaming before they killed them. Six months after Norris's release on

In 1979, Bittaker (shown above) and Norris outfitted their van for crime and named it the "Murder Mack." In this van they cruised the streets of Los Angeles, including La Crescenta, looking for young girls to abduct, rape, torture and murder, many of them on a fire road in the San Gabriel Mountains. It's astounding to consider that some victims willingly got into this van. *Courtesy of murderpedia.org.*

June 24, 1979, he teamed up with Bittaker for their first murder. They decided to abduct girls from beach areas. Redondo Beach and Venice were their main targets. They would then drive the girls to the foothills, where the girls were tortured and then murdered. The two were very methodical. They outfitted a van for their murderous work. They named their van the "Murder Mac." For about five months, they practiced picking up girls. These were test runs. Cindy Schaefer, sixteen, was picked up in Redondo Beach. She was driven to the foothills, raped and then strangled with a coat hanger. She asked to be allowed to pray before she was killed. The two did not honor her request. Andrea Hall, eighteen, was murdered in July. She was their second victim and was abducted on Pacific Coast Highway (PCH). She was raped and stabbed in the ears with an ice pick.

In September, there was a double murder. Jacky Gilliam, fifteen, and Jacklyn Lamp, thirteen. The two were kept alive for two days of sexual torture. They were finally killed on October 31. Shirley Ledford, sixteen, was dumped on a lawn in Sunland, just to stir up the locals. Norris and Bittaker dumped some of their victims off Angeles Crest for the coyotes to dispose of. The two had accumulated five victims in five months. Their victims were strangled with coat hangers, smashed in the head with sledgehammers and stabbed in the ears with ice picks. In a final act of depravity, they tape recorded Shirley Ledford's dying agony.

Norris bragged of his murder to a friend. His friend went to the police, and Norris was arrested. He quickly confessed and put most of the responsibility on Bittaker. Norris testified against Bittaker in return for a lighter sentence. While investigating the murders, five hundred pictures of young girls were discovered in Bittaker and Norris's possession. Nineteen of these women were determined to be missing. The two were convicted of five murders, but police believed that there may have been as many as forty girls murdered. Bittaker was sentenced to death in 1981; he is still fighting to stay alive.

Norris was given a sentence of forty-five years to life; he was eligible for parole in May 2010. One of the conditions of his conviction was that the tape recording of Ledford's torture would be played at his parole hearings. It is extremely unlikely that Norris will ever walk free again.

TRAGEDY AT SAFEWAY, 1979

This case has always haunted me. The murder of a child is always terrible. We owe it to our children to keep them safe, and when we fail to do so, our whole society fails. Three-year-old Jennifer Slagle was shot during an exchange of gunfire between her father and two men who were holding up the Safeway Grocery store at 3233 Foothill Boulevard in La Crescenta. Jared Slagle, her father, worked as a civilian crime lab photographer for the LAPD. He was also a reserve sheriff's deputy and had been for five years. Manuel Pérez, thirty-seven, was wounded in the robbery. He was charged with robbery and murder when he sought medical attention at County Medical Center at the University of Southern California.

Chapter 8
MODERN TIMES

ANGELES CREST CRIMES

Angeles Forest has been called Los Angeles's backyard. Twenty-five miles north of Los Angeles, its hiking trails, canyons and camping areas provide recreation for the city. In the winter, you can go from the seventies in the valley to snow in the mountains in less than an hour. Unfortunately, its rugged beauty provides many places for murderers to dispose of their victims. A deputy sheriff said, "If I yelled out for every dead person buried here to stand up, it would look like Venice Beach." Here is just a sampling of the many murders and suicides reported in recent times:

Mrs. Rachel Sparling's body found five miles north of La Cañada (March 18, 1977).
Burned body found in campground (February 2, 2006).
Human remains found near Mount Wilson (January 4, 2008).
Suicide on Big Tujunga Canyon Road (January 2009).
Body found on Angeles Crest Highway (May 14, 2009).
Transient wanted for questioning in Angeles Forest fire (October 15, 2009).
Angeles Crest Murder (May 22, 2012).
Suicide at Big Tujunga Canyon (December 1, 2012).
Human remains found at Big Tujunga Canyon (January 19, 2013).

BRUTAL ATTEMPTED MURDER, 1990

Ebrahim Joseph Haddad, thirty-nine, was bad news for La Crescenta. La Crescenta returned the favor. Haddad was charged with robbery, rape and attempted murder. He was tried in February 1992. He was accused of threatening a thirty-three-year-old woman, raping her in her home with a shovel handle, slashing her breasts and stabbing her with a knife. On February 11, 1992, the jury found him guilty of robbery, two counts of rape with a foreign object, burglary and aggravated mayhem. The jury initially deadlocked on the attempted murder charge. The judge of the Pasadena Superior Court, Terry Smerling, urged the jury to try and reach a verdict. On February 13, 1992, the jury found Haddad guilty of attempted murder.

JILTED BOYFRIEND SUICIDE AT THE HIGH SCHOOL, 1991

The year 1991 was a bad one for the foothills and Crescenta Valley High School in particular. There was a suicide at the school, a murder involving one of its students and the downfall of Crescenta Valley High School alum Officer Lawrence W. Powell, famous in the Rodney King Case. Read on.

The teen years are remembered by some as the best of times and by others as the worst of times. It is a time of physical and emotional turmoil. The emotional toll can be greatly increased by a failed romance. David Dediego, a twenty-two-year-old Montrose resident, was sitting in his car at the CVHS upper parking lot on Ramsdell. He was trying to reconcile with his former girlfriend. She was a seventeen-year-old senior at the school. When he failed to reconcile, he handed her a suicide note before shooting himself.

LAWRENCE POWELL, 1991

Crescenta Valley's Finest

On March 3, 1991, Rodney King was stopped for speeding on the 210 freeway in Lake View Terrace. He had been drinking and admitted to speeding. He also admitted to initially resisting arrest. Rodney was a petty criminal whose life was, and always would be, a mess. In 1987, he had

pleaded "no contest" to domestic abuse. In 1989, he received a two-year sentence for robbing a convenience store and assaulting the clerk. On the night of March 3, 1991, he had endangered his life, the lives of other drivers on the road and the lives of the police officers by speeding on the foothills freeway. The police claimed that Rodney was uncooperative and dangerous. After using a Taser on him three times, the police knocked him to the ground and delivered fifty-six baton blows in eighty-one seconds. Forty of those blows were delivered by officer Lawrence Powell, a Crescenta Valley High School graduate and three-year veteran of the LAPD. Fortunately for King, some of the blows missed their target. Four officers were directly involved in the beating: Officers Stacey Koon, Theodore Briseno, Timothy Wind and Lawrence Powell. Many other officers were on the scene at the time or arrived shortly thereafter. An additional CVHS graduate, a newly minted rookie, was also on the scene but was merely a witness. The two officers most directly involved were Sergeant Stacey Koon and Lawrence Powell. Powell was the one who attempted and landed the most blows in the beating. Later at the station, he remarked to King, "We played some hardball tonight."

The Los Angeles minority community had protested such action many times in the past. Their concerns had been ignored. This time, however, things were different. There was a videotape of the incident. After reviewing the videotape, the district attorney charged the four officers with "Assault with a Deadly Weapon" and "Use of Excessive Force." During the assault, King was hit in the face. This is against LAPD protocol. Powell stated to a brother officer, "I haven't beaten anyone this bad in a long time." Journalist Lou Cannon, author of *Official Negligence: How Rodney King and the Riots Changed Los Angeles and the L.A.P.D.*, described Powell as a "uniformed accident in waiting." Cannon quoted an African American officer who said that Powell "treated everyone like crap." Other officers described Powell as "immature and elitist." Prosecution investigator Jack White called Powell "an overaggressive and slightly sadistic police officer of questionable judgment." Previous excessive-force claims against Powell had amounted to $70,000. He had been identified as striking a handcuffed prisoner. Officer Briseno, acquitted of the charges, said that Powell was "a very callous individual, and the type of policeman you don't want on the streets."

Most disturbing was the hint of racism that can be heard in Powell's statement about a black family involved in a domestic dispute. Powell had handled this domestic dispute shortly before the beating, and he referred to this family as "gorillas in the mist".

The officers were tried in Simi Valley. The jury consisted of ten whites, one Asian and one hispanic. The four officers were acquitted on the assault charges, but the jury was deadlocked on the excessive force charge against Powell. The riots were the result. The riots led to fifty-two deaths and $1 billion in property damage. Perhaps the high point of King's life occurred during the riots, when he spoke out against the violence, saying, "Can't we all just get along?" Many people felt that a miscarriage of justice had occurred. The four officers were indicted on federal charges for violating the civil rights of Rodney King. With a more diverse jury in Los Angeles, Powell and Koon were convicted and served thirty months in a minimum-security prison. After his release from prison, Stacey Koon made a career out of his conviction. Today, Officer Powell is married and has two children. Five years after his conviction, he told CNN that "King was a puppet for his lawyers. He's just a petty criminal." Powell no longer gives interviews.

Rodney King's life continued its path to self-destruction. He was arrested and charged with assaulting his wife and daughter. He became an alcoholic and was arrested multiple times and charged with DUIs. He was awarded $3.8 million in civil damages, all of which he spent. At the end of his life, he was unable to make his house payments. He was found drowned in his pool on June 17, 2012, in his home in Rialto, California. He was forty-seven years old.

MURDER ON PROM NIGHT, 1991

The murder of Berlyn Cosman was a particular tragedy for the foothill community. Berlyn showed such promise. She was an All-League Basketball player who had earned a four-year scholarship to play at Western Missouri State. In addition to her athletic ability, she was also a great student. I remember her sitting up front in my American history class. She was always attentive and questioning. She was sociable, outgoing and had a positive attitude. Berlyn was murdered by Paul Crowder, a nineteen-year-old high school dropout who had no business at the prom after-party that he crashed. He shot Berlyn in the head with a .357 Magnum while she was sleeping. One good thing to come out of this tragedy was a new event: Crescenta Valley Prom Plus. The community now provides a safe and fun venue for a supervised all-night party that takes place after the

CVHS prom every year. Hopefully, there will never be a tragedy of this magnitude ever again.

According to witnesses, Crowder spent the night waving the gun around dry firing it while pointing it at people, including himself. Crowder's defense was that "the gun had accidentally fired, while I was putting it away." He had not attended the prom, and he stated that

There is a plaque dedicated to the memory of Berlyn Cosman located just under a basketball hoop that she often used. It can be found in Montrose Community Park, at the end of Clifton Place. The plaque reads, "In memory of Berlyn Cosman, 1991: a talented young woman and athlete." *Photo by Mike Lawler.*

he had brought the gun and a 12-gauge shotgun to the party to act as a bodyguard for Brian Burke. Burke's date had been threatened by a former boyfriend. It turned out that the only protection needed was from Crowder himself. During the trial, twelve witnesses and friends admitted to either lying or misleading law enforcement during the investigation. It took the jury one day to find Crowder guilty of second-degree murder. He was sentenced to seventeen years to life. Since his conviction, Crowder has been granted parole by the parole board. Governor Brown vetoed the parole. Brown stated that Crowder was dealing in drugs and gang communications while in prison. In 2001, parole was denied by Governor Schwarzenegger. The Anaheim Police Department has stated that Crowder has taken no responsibility for Berlyn's death. He has made little attempt at rehabilitation. On December 19, 2012, the parole board once again denied parole to Crowder. The board said that if Crowder were released, he would be a danger to others. His next parole date is in 2017. Currently, Mark Cosman, Berlyn's father, is in favor of Crowder's parole. Berlyn's mother, Susan, opposes parole. The greatest regret is that it was later reported that Crescenta Valley High School students had known Crowder had brought a gun to the high school campus before the prom. No one had informed any teacher or administrators. If they had, the entire tragedy might have been avoided.

PHOTOGRAPHER MURDERS MODEL, 1993

The body of Linda Sobek, twenty-seven, was found in a shallow grave in the Angeles National Forest. She was a model and former Los Angeles Raiders cheerleader. She was kidnapped and murdered by Charles Rathbun just hours before her fitting for her first TV role. Rathbun had enticed Linda into the mountains on a supposed photo shoot for *Auto Week* magazine. Rathbun claimed to have accidentally killed Linda by demonstrating how to do donuts (to turn quickly in tight circles) in her car and accidentally hitting her. He said he then panicked and ditched the body in desperation. The medical examiner found no evidence of Linda having been hit by a car. Rathbun was charged with murder and pleaded not guilty. According to the district attorney, Linda had been strangled by Rathbun as he sat on her chest.

Rathbun was a photographer specializing in cars. He was considered first rate in his specialty and was known to have a temper. He often threw things when he was angry and was unable to admit to mistakes he had made. This last characteristic was apparent at his trial, as he never showed any sign of remorse. Rathbun had been an average high school student. He grew up in Ohio, where he had been charged with rape. He was acquitted of the charges. Rathbun was a disorganized and careless killer. He had dumped pictures of Sobek, a date book and a receipt for a Lexus 450 in a garbage can on Angeles Crest Highway. Police tracked down Rathbun to his Hollywood home, where he was found drunk and threatening to kill himself. He had already wounded a female companion who was a reserve deputy.

Linda Sobek was a professional cheerleader for the short-lived Los Angeles Raiders and, afterward, made her living as an actress and professional photography model. Photographer Charles Rathbun hired her as a model for an automobile photo shoot and murdered her while doing location shots in the Angeles Forest. *Courtesy of murderpedia.org*

Rathbun confessed, but because police did not properly read him his rights, his confession was considered invalid. In prison, Rathbun made a supposed suicide attempt. He was also thought to have been involved in the murder of Kimberly Pandelious, a part-time model. Her body was found in a shallow grave, very close to where Sobek's body was found. But it was eventually determined that he was not responsible for her death. In the Sobek case, the jury found him guilty. The judge, citing the violent and cruel death, stated, "Her death was an unspeakable horror." He then proceeded to sentence Rathbun to life in prison plus eight years.

BARTENDER MURDERS BAR OWNER, 1999

Sheriffs' deputies found the badly beaten body of James Cummings in his bar Up the Hill. Cummings had owned the bar for twenty-two years and was a resident of La Cañada-Flintridge. Martin Higgins, fifty-nine, was arrested in Laughlin Nevada. He had in his possession Cumming's car and driver's license. Higgins was drunk at the time of his arrest. Higgins tended bar at Up the Hill. He allegedly stole $1,000 cash and an $8,000 mandolin. He was being held in Vegas on a parole violation. Higgins was described as a loner and drifter.

Up the Hill is a classic neighborhood bar and was even featured in a book titled *The Dive Bars of Los Angeles*. Located in a converted house at 2856 Foothill Boulevard, the bar features no-nonsense, cheap, strong drinks, served out to mostly locals. In 1999, the bar's owner was found on the floor of the bar, beaten to death, apparently by the bartender. *Photo by Mike Lawler.*

New Leads in Cold Case Murder, 2000

The bodies of Harold "Skip" Tillman and his wife, Joni, were found buried together in a shallow grave in a remote area of Yucaipa. San Bernardino's sheriffs' deputies were notified that the body of a prized Maltese named Teddy had been found by a hiker. The Maltese belonged to the Tillmans. The hiker called the name on Teddy's collar, and no one answered the phone. He then notified the sheriffs' department. Investigation of the site where the dog was found led to the discovery of the Tillmans' bodies. Skip Tillman, an accountant, and Joni, a homemaker, were last seen dining at JJ's Steakhouse in Pasadena on February 6, 2000. Witnesses reported seeing their vehicle later that evening as it entered the driveway of their home in the 5600 block of Bramblewood Road, La Cañada. Three days later, their bodies were found strangled and buried in a wash in Yucaipa. The neighbors were stunned to hear the news of the killings. Mike Miller, a retired attorney, stated, "These were people I knew, liked and saw everyday." He speculated that either bad things happen to good people or people who are good in every other way could be involved in something dangerous. The last months of the Tillmans' lives had been contentious. Clothing designer David Hayes claims that Skip, who was his accountant, had embezzled $1.7 million from him. He alleged that Skip had forged his signature on forty checks. Hayes's office manager was suing Skip for $100,000. The Tillmans were also in litigation with Joni's half brother, Craig Elliot.

The murder investigation trail ran cold in 2008. In 2012, a witness described a man seen in the area at the time of the murders. He described a menacing looking man with long hair and a baseball cap driving a Ford Bronco. This man was described by San Bernardino's Sheriffs' Department as a "Person of Interest." This is considered a cold case that is still ongoing.

Valley View Elementary School Murders, 2000

On the night of July 23, 2000, Frank Hoogenhuizen was to receive the greatest shock of his life. He found the bodies of Blaine Talmo, fourteen, of La Crescenta and Christopher McCulloch, thirteen, of La Cañada Flintridge. Frank said at first, he thought the boys were asleep. On closer inspection, he knew something very dark had taken place. One boy had a large, discolored rock pressed against his head. The other lay under a playground slide. A

twelve-foot-long bench rested on his body. One of the metal legs lay across his throat. The residents wondered how such a horrible thing could happen in their relatively quiet community. The boys were eighth grade students at Rosemont Middle School. Fifteen-year-old Michael Demirdjian would be charged with the murders. Deputy District Attorney Bishop said it was a drug deal gone bad. He claimed that Demirdjian was angry after fronting $660 for drugs and receiving nothing in return. According to the district attorney, he plotted to ambush the dealer, Adam Walker, nineteen. The two boys became victims because they had introduced Demirdjian to Walker. Demirdjian had stated in his defense that he had witnessed the murders but did not participate. He stated that he and the boys had been drinking and smoking marijuana at Valley View Elementary School. He claimed that Walker and McCulloch began to argue, and Talmo tried to intervene. According to Demirdjian, Walker attacked and strangled the pair. Walker was never charged in the murders. Demirdjian's first trial ended in an eight-to-four hung jury. The district attorney was to try him again seven months later. He was found guilty and sentenced to two consecutive twenty-five-years-to-life sentences. Demirdjian's defense attorney, Charles T. Matthews, maintained that Demirdjian was not capable of killing two boys of their size

Fifteen-year-old Michael Dermirdjian is seen here at his trial in 2001. He was convicted of the murders of two boys and sentenced to consecutive twenty-five-years-to-life terms. Although the evidence pointed strongly to Dermirdjian's guilt, the verdict is still controversial to some. *Courtesy of the* Glendale News *Press.*

Valley View Elementary School, seen here from the intersection of Orange and Maryland Avenues, is a typical suburban school. The horrific murder that took place on the playground of the school in the summer of 2000 was far from typical and shocked the normally peaceful neighborhood. *Photo by Mike Lawler.*

by himself alone. It would have required a larger, strong person. Matthews played the race card and claimed bias in the decision. Demirdjian was half black and the adopted son of Armenian parents. Glendale Police sergeant Dennis Smith said the forensic evidence was clear. Investigators found shoes at the Demirdjian residence that matched the footprints at the scene of the murder. Blood was found at three locations within the Demirdijian home. Demirdjian was also in possession of Talmo's wallet. In this case, three families have been injured. Gary and Sossi Demirdjian still believe in their twenty-seven-year-old son's innocence and continue to try to prove it. Christopher McCulloch's mother, Aileen Bristow, is an active member of the Crescenta Valley Drug and Alcohol Coalition.

BODY FOUND IN MOUNTAIN WATER TANK, 2003

In November 2003, a hiker on a fire road in the Verdugo Mountains stopped briefly at an old wooden water tank kept full to refill mountain fire trucks. The hiker had been this way several weeks earlier and had

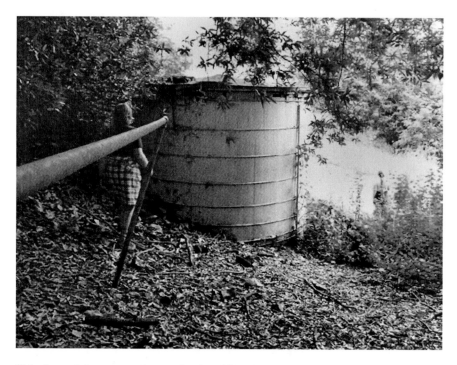

This photo of the water tank was taken by a hiker the day before the body was found. After the shot was taken, the hiker in the photo climbed up and peeked into the tank but, having no light, was fortunate to not see the skeletal remains in the water. The victim's discarded clothing can be seen on the ground and on the edge of the tank. *Courtesy of the Historical Society of the Crescenta Valley.*

smelled an odor of decomposition at that time, but he hadn't checked the tank. This time, he had come equipped with a flashlight to look into the dark water tank. When he looked through the opening at the top of the tank, he was met with a grisly sight: a mostly decomposed and skeletal body floating in the dark green water. A T-shirt, Levis and a pair of boots were near the opening, indicating perhaps someone had climbed into the tank for a swim and then couldn't get out. A coroner crew used a chainsaw to cut an opening in the side of the wooden tank to retrieve the remains. The body was never identified.

METROLINK DISASTER, 2008

Robert M. Sanchez, forty-six, of Hermosa Avenue, Montrose, was killed when the Metrolink train he was conducting collided with a Union Pacific freight train. Neighbors described him as a loner but nice. The accident was horrific. Twenty-five people died, and 135 more were injured. Eighty-five victims were sent to thirteen area hospitals, 46 of whom were critically injured. The accident happened at 6:16 p.m. on a Friday. The trains collided on a curved section of single track. The National Transportation Safety Board (NTSB) said that the Metrolink ran through a red signal before entering the single track. The Union Pacific freight train had the right of way. This was the deadliest accident in Metrolink history.

Captain Ruda said his firefighters had never seen such carnage. Austin Walbridge, a passenger, said that the train was a bloody mess. The early calls for assistance did not relate how bad things were. The first responders could not believe the magnitude of the disaster and were overwhelmed by the devastation. Eventually, all heavy rescue equipment available in the city was called to the scene. Hundreds were involved in the rescue attempts. The Metrolink train weighed 250,000 pounds. It had 222 people on board. The freight train had two locomotives, weighing 418,000 pounds each. They collided at forty miles per hour. The Metrolink engine telescoped into the passenger compartments, and all three locomotives derailed. Property damage was set at $7.1 million, but this was the least important aspect of the accident. Many survivors had extensive injuries: massive head and chest trauma, collapsed lungs, rib fractures, pelvic fractures, blood in the brain and multiple facial fractures. Liability would easily reach $200 million, the maximum allowed by law. The NTSB faulted the engineer, Robert M. Sanchez. He missed the red signal because he was sending a text message twenty-two seconds before the collision. Sanchez was working an eleven-hour split shift after a nine-hour layover from the previous day's shift. Sanchez began his split shift at 5:54 a.m. He finished his morning shift at 9:26 a.m. after having sent forty-five text messages at a rate of fifteen per hour. At 3:03 p.m., he began his afternoon run, and at 5:21 p.m., he had received seven text messages in 113 minutes. At 6:22 p.m., he sent his last text message.

The freight train engineer applied his brakes two seconds before impact. Sanchez never did. Records from March 3 showed that Sanchez

had allowed a train enthusiast to ride in his cab several days before the crash. He was planning to allow the enthusiast to operate his train at a future date.

THE SANTA CLAUS KILLER, 2008

Holy Redeemer Catholic Church, which is located in Montrose, California, has contributed more than one incident to the criminal lore of the valley. Perhaps the most spectacular was a Christmas Eve massacre by the Santa Claus killer. Bruce Pardo, forty-five, of Sunset Avenue, Montrose, was a graduate of John H. Francis Polytechnic High School and California State University–Northridge. He worked for JPL as a software engineer. He became engaged to a co-worker. She paid for the wedding for 250 guests and a Tahitian honeymoon. He never showed for the wedding and stole the remaining savings of his bride to be. He blew all the money in Palm Springs. He had no sense of responsibility.

In 2001, Pardo was living with his girlfriend, Elena Lucano, and their thirteen-month-old son. Pardo was watching television when his son fell in the pool. Matthew survived but had severe brain damage. He is now a paraplegic. Neither Elena nor Matthew ever saw Pardo again.

Pardo went on to marry Sylvia Ortiz, forty, in January 2006. They moved to Montrose. Pardo seemed to settle down and became a regular usher at Holy Redeemer Church. The marriage lasted until March 2008, when Syvia claimed that Pardo had become distant and miserly. Sylvia asked to be able to use the home so that her daughter could finish out the school year. Pardo refused. He was working for ITT for $122,000 a year. He defied a court order to pay $1,785 a month in child support.

During the time that he was planning the murders, he ate lunch a few times a week at the Montrose Bakery and Cafe. In the months leading up to the massacre, he carefully planned and stockpiled weapons. On a visit to Iowa, he bought sixteen handguns with eighteen bullet clips. He had previously purchased five other handguns in California. On Christmas Eve 2008, when he was scheduled to usher at Holy Redeemer Church, Pardo went to his former in-laws home in Covina, California. Inside, there was a Christmas Eve party with twenty-five guests that was just beginning to break up. He was dressed in a custom-made Santa suit with extra pockets for guns and ammunition. An eight-year-old girl opened

the door to greet the guest. She was delighted to see Santa Claus. Pardo promptly shot her in the face. He then emptied four handguns on the twenty-five guests and, next, began to spray the interior of the house with high octane racing fuel. This is where his plan went wrong. The flame of a candle ignited the fuel prematurely. Pardo suffered second- and third-degree burns on his hands, arms and legs. Part of his fancy Santa suit melted to his legs. Pardo had planned to escape to Canada. He had a ticket and $17,000 in cash on him. Severely injured and in great pain, he drove to his brother's house in Sylmar, where he committed suicide. He left behind a booby-trapped car with two hundred rounds of ammunition inside. Pardo was described by neighbors as an unassuming religious man who tended his garden and served regularly as an usher at evening mass. The neighbors said he was "the nicest guy you could imagine." Pardo left nine dead and three wounded. He murdered his former wife, Sylvia, her two brothers, their wives, her sister and a nephew. The victims' ages ranged from seventeen to eighty. The eight-year-old who was shot in the face survived. Thirteen children were orphaned by Pardo's actions. It would be the largest mass killing in Los Angeles County history.

RUNAWAY TRUCK AT ANGELES CREST, 2009

Angel Posca and his twelve-year-old daughter, Angelina, had just exited the 210 freeway. They were stopped at Angeles Crest Highway and Foothill Boulevard and were waiting to make a left turn onto Foothill. They had no idea that a runaway twenty-five-ton eighteen-wheeler was about to end their lives.

Marco Costa, forty-five, a man who had served fifteen years as a pastor in Massachusetts before becoming a truck driver, careened down Angeles Crest Highway after losing his breaks. His truck slammed into five cars and crashed into the Flintridge Bookstore and Coffee House. The collision killed Angel and Angelina. Eleven other people were injured, four critically.

Costa was originally charged with reckless driving, two counts of murder and two counts of involuntary manslaughter. Bail was set at $341,000. Costa was first represented by Steve Meister. He fired Meister after accusing the lawyer of sabotaging his case and having a conflict of interest. Costa also charged that he was a victim of selected prosecution and asked to defend

This is the view from the crash site at Foothill Boulevard, looking up the long, steep grade of the Angeles Crest Highway. The wreckage of several cars was pushed through the intersection and into the buildings on the other side by the runaway truck. Deep gouges in the sidewalk from the horrific impact are still visible. *Photo by Mike Lawler.*

himself. Superior Court judge Lisa Lench told Costa, "You have to know what the law says." She did not think that Costa, with only a high school diploma, would be up to the challenge.

The defense served subpoenas to the mayor of La Cañada, Don Voss; Los Angeles County sheriffs; Cal-Trans, the trucking company; and the Department of Public Works. The prosecutor, Carlina Lugo, contended that Costa should not have been on Angeles Crest Highway. Trucks of this size were prohibited from using the highway. Multiple signs were posted to that effect. Juan Palomino, an off-duty firefighter, testified that he had flagged down Costa because of his smoking breaks. Palomino advised Costa to turn around or take an alternative route. He drew Costa a map. Costa instead poured water onto his breaks and continued down the highway. Defense attorney Edward Murphy contended that Costa did everything possible to avoid the accident. Prosecutors contended that Costa could have taken other actions, such as using the mountain to his right to slow the truck. Costa escaped the second-degree murder charges but was convicted of involuntary manslaughter. He was sentenced to seven years and four months, which means he will most likely serve only three years. He expressed his intention to appeal his conviction in December 2012. A month later, he decided not to challenge the conviction. He cited his desire to put the incident behind him and get on with his life. The family of Angel and Angelina Posca filed a civil suit against Marco Costa, the trucking company he worked for, Cal-Trans and the City of La Cañada–Flintridge. The City of La Cañada–Flintridge was not held responsible as it pointed out that several weeks before, it had requested that big rigs be banned from Angeles Crest. It had made this request after a big rig carrying seventy-eight thousand pounds of onions had lost its brakes and crashed into some cars in a parking lot just seven months prior.

The Posca family was awarded $900,000 out of Costa's $1 million insurance policy. The other $100,000 was to be divided by twenty-five other claimants. Cal-Trans paid the family $2.25 million. Cal-Trans also made improvements to Angeles Crest, providing a truck escape meridian. The meridian has proved ineffective as accidents still occur. In August 2011, a pickup truck collided with a car, which then went out of control and crashed into Melody's Nails, located in the 900 block of Foothill Boulevard. No injuries occurred.

STATION FIRE, 2009

The station fire in 2009 was the largest and deadliest in Los Angeles County and the biggest in California. It consumed 160,577 acres. It burned 209 structures, including 89 homes. It claimed two firefighters' lives. The combination of high temperatures in excess of one hundred degrees, low humidity and tinder dry conditions were perfect ingredients for the station fire. The fact that it was the work of an arsonist makes it even more tragic. The fire threatened the communities of Glendale, La Crescenta, La Cañada, Little Rock, Altadena, Sunland and Tujunga. The communication network on top of Mount Wilson was in danger, as was the observatory. Hundreds of people had to evacuate their homes. By far, the greatest loss was the death of the two firefighters who tried to flee the fire. Their truck plunged off a cliff, killing them in the process. The arsonist has yet to be identified or brought to justice.

SUICIDE AT CRESCENTA VALLEY HIGH SCHOOL, 2012

Drew Ferraro, a fifteen-year-old sophomore, jumped from a three-story building at CVHS. He leapt to his death at the beginning of lunch as dozens of teens watched. School officials were quick to deny that bullying had anything to do with Drew's death. However, friends contended that Drew had been bullied for being different. Megan Dorsy said that Drew did not want to go to school anymore because of the harassment. School officials pointed out that Drew left four suicide notes. Not one of them mentioned bullying as a reason for taking his own life. Drew's parents maintain that his journals revealed that he had been the target of harassment, name calling and shoving. His mother, Diana, feels that his death taking place at school was a major statement of his feelings.

ANGELES FOREST MURDER, 2013

A freshly dug grave just off Big Tujunga Canyon was recently discovered. Initially, police found a blood trail but no remains. During further investigation, clothes and bones were discovered. The bones were

identified as an animal of some sort, and police initially believed that the animal could have been used in a ritual. On January 19, 2013, human remains were discovered by Montrose Search and Rescue. The remains were that of a male. On January 30, those remains were identified as twenty-five-year-old Nicholas Carter of Glendale. On February 13, Erik Peason, twenty-one, and Donald Thurman, twenty-six, of Burbank, were charged with murder. The two were accused of beating Carter to death and stealing his credit cards.

TRAGEDY STRIKES LA CAÑADA HIGH SCHOOL, 2013

Campbell Forest Taylor, seventeen, jumped to his death at La Cañada High School. Campbell was described as ambitious and outspoken. He appeared to have everything going for him. He was active in the school theater and the school paper. He was not afraid to take on controversial issues. He was bold and blunt, according to Kevork Kurdoghzian, the former editor of the school newspaper. Kevork said of Taylor, "He was a visionary. He was smart." Taylor reportedly had his future planned out: college in Sacramento and ROTC in hopes of becoming a pilot. The death of one so young with so much to live for is always shattering to parents, the school and the community. Three suicides have been covered in this work. There were two others, one at Flintridge Sacred Heart Academy and one at Clark Junior High. School communities need to be constantly alert in order to detect and help suicidal teens. Teens do not realize that suicide is a permanent solution to a temporary problem.

ABOUT THE AUTHORS

Gary Keyes taught U.S. history, government and sociology at Crescenta Valley High School in La Crescenta for thirty-nine years. Currently, he is an adjunct professor of social science at Glendale Community College in Glendale, California. As a resident of the foothill communities for the past forty-five years, he became interested in local history when he helped members of his son's Boy Scout troop obtain their Citizenship in the Community badges. Today, he lives in La Cañada with his very supportive wife of forty-eight years.

Mike Lawler was born with a passion for history and spent much of his childhood digging holes in his yard in La Crescenta, looking for clues to the area's history. As a teenager, he was a student of Gary Keyes and was fascinated with Keyes's focus on some of the darker aspects of history. As an adult, he became a community leader in bringing local history to life with the Historical Society of the Crescenta Valley and, in particular, was thrilled to once again team up with Keyes to air Crescenta Valley's "dirty laundry."

Visit us at
www.historypress.net
..
This title is also available as an e-book